THE BEAL
COLLECTION
OF AMERICAN ART

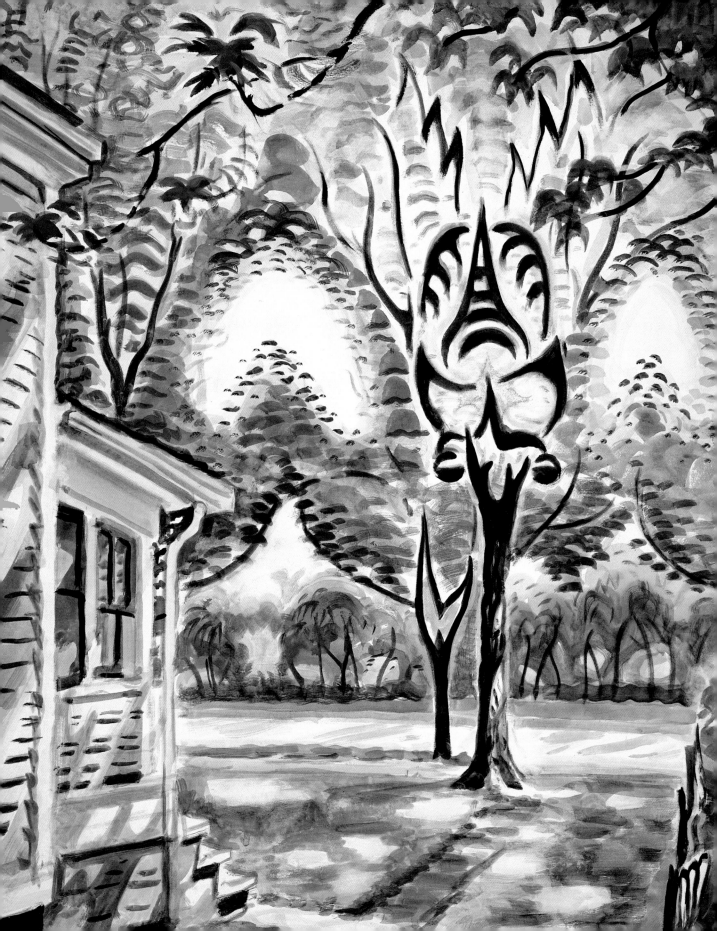

THE BEAL
COLLECTION
OF AMERICAN ART

Essay by Henry Adams

Catalogue and Checklist
by Linda Batis
with the assistance
of Ruth Edelstein

THE CARNEGIE MUSEUM OF ART
PITTSBURGH, PENNSYLVANIA 1994

Published on the occasion of the exhibition
Toward Modernism: American Art from the Beal Collection
at The Carnegie Museum of Art, Pittsburgh, Pennsylvania
April 30–July 17, 1994.

Corporate support for the exhibition is provided by Reed Smith Shaw & McClay.

Library of Congress Cataloging-in-Publication Data

Carnegie Museum of Art.
 The Beal Collection of American art / essay by Henry Adams :
catalogue and checklist by Linda Batis with the assistance of Ruth Edelstein.
 p. cm.
 "Catalogue for the exhibition 'Toward modernism: American art from
the Beal Collection' (Apr. 30–July 17, 1994)".
 1. Modernism (Art)–United States–Exhibitions. 2. Art,
American–19th century–Exhibitions. 3. Art, American–20th
century–Exhibitions. 4. Beal, James H.–Art collections–
Exhibitions. 5. Beal, Rebecca J.–Art collections–Exhibitions.
6. Art–Private collections–Pennsylvania–Pittsburgh–Exhibitions.
7. Art–Pennsylvania–Pittsburgh–Exhibitions. 8. Carnegie Museum
of Art–Exhibitions. I. Adams, Henry, 1949– . II. Title.
N6510.5.M63C37 1994 709'.73'07474886–dc20 94-1833
 CIP
ISBN 0-88039-025-5

Edited by Gillian Belnap
Designed by Patricia Inglis

Composed electronically using QuarkXPress® on the Apple® Macintosh® computer
The type is Adobe™ Times
Printed by Schneidereith & Sons, Baltimore, Maryland
The text paper is 80 pound LOE Dull, the cover is 100 pound LOE Dull

Cover: CHARLES DEMUTH, *Three Apples with Glass* (detail), c.1925

Frontispiece: CHARLES E. BURCHFIELD, *Sun Glitter* (detail), 1945

CONTENTS

7 Foreword
PHILLIP M. JOHNSTON

11 The Beal Collection
HENRY ADAMS

65 Chronological List of the Beals' Major Acquisitions

69 Catalogue of the Exhibition
LINDA BATIS, RUTH EDELSTEIN

105 Checklist of Works Not Exhibited
LINDA BATIS, RUTH EDELSTEIN

Individuals like Rebecca and James Beal have been the creators and nurturers of America's art museums. The Beals' collection of American art — to which this catalogue is devoted — is their generous legacy to The Carnegie Museum of Art. It includes important and beautiful works and bolsters the Museum's existing strengths in American modernism and paintings by Pennsylvania artists. Surely it is one of the most significant collections to be given to the Museum, along with those of the Scaife Family, Ailsa Mellon Bruce, and Charles J. Rosenbloom. Moreover, all of these gifts imbue the Museum's collection with some of the character and personality of the collectors.

Over their lifetimes Rebecca and James Beal were dedicated, thoughtful, and intelligent patrons of the Museum. James Beal served as a trustee of Carnegie Institute for many years and, additionally, chaired the Museum of Art Board. Rebecca Beal, artist, scholar, and collector, understood, as did her husband, the Museum's essential business — to foster the enjoyment and study of works of art. Therefore, not only did they give their works of art to benefit their community, but they established the James H. Beal Publication Fund. This fund provides annual support for the Museum's publications program, which ensures that the Museum reaches an audience beyond those who visit our galleries and contributes to an ongoing dialogue about works of art. Indeed, the Beal Publications Fund furnished considerable resources for this catalogue.

Henry Adams's essay on Rebecca and James Beal gives a glimpse of these two extraordinary individuals and vividly details the evolution of the collection that is now the Museum's. Henry Adams, curator of fine arts from 1982 to 1984, was the last of the Museum's

curators to know the Beals personally; we are particularly grateful to him for sharing his memory of them, especially of Mrs. Beal. He benefitted from the recollections of Leon Arkus, director emeritus of the Museum, and James M. Walton, president emeritus of Carnegie Institute, both of whom knew the Beals over many years.

The catalogue of the Beal collection that Dr. Adams's essay introduces has been prepared by Linda Batis, assistant curator of fine arts, who was assisted by Ruth Edelstein and Karen Oster. Patty Inglis crafted its design. Both its editing and production management are the work of Gillian Belnap, head of publications, and Elissa Curcio, publications assistant. The Museum's curator of fine arts, Louise Lippincott, has been responsible for the overall direction of this cataloguing project as well as the organization of the exhibition that it accompanies, *Toward Modernism: American Art from the Beal Collection.* I am deeply grateful to them all for the fine quality of their work. The result is a publication that joins the Museum's two earlier publications of its American art collection, *American Drawings and Watercolors* (1985) and *American Paintings and Sculpture to 1945* (1992), which in combination fully document the Museum's American art from the nineteenth century to World War II.

Members of the Beals' family also have been extraordinarily generous to the Museum. We are pleased that they have shared Mr. and Mrs. Beal's desire to see this collection become a part of the Museum. We are indebted in particular to Joseph Van Buskirk, George Van Buskirk, and David Van Buskirk who made possible additional gifts of Edward Hopper's *Tree* and Dong Kingman's *House in Brooklyn.* They also graciously shared photographs of and information about the Beals and lent several watercolors by Rebecca Beal for inclusion in the exhibition.

Finally, I extend my gratitude to the many supporters of this exhibition and catalogue. Their number in itself expresses the high esteem of our community for Rebecca and James Beal and the regard they feel for the Beals' generosity to the Museum and thereby to our city: R. K. Mellon Family Foundation; Reed Smith Shaw & McClay; Robert S. Waters Charitable Trust; Mr. and Mrs. G. Nicholas Beckwith III; Mr. Charles M. Beeghly; Mrs. George B. Berger, Jr.; Buncher Family Foundation; David Van Buskirk, M.D.; Mr. and Mrs. George Van Buskirk; Mr. Joseph Van Buskirk; Mr. and

Mrs. John P. Davis, Jr.; Mr. and Mrs. Ralph H. Demmler; Mr. Robert J. Dodds, Jr.; Mr. and Mrs. Milton Fine; Mrs. Edith H. Fisher; Mrs. David M. Gilmore; Mr. and Mrs. O. Henry Gruner III; Mr. William P. Hackney; Mr. and Mrs. Henry L. Hillman; Mr. Henry P. Hoffstott; Mr. and Mrs. Edward Hoopes; Mr. and Mrs. Thomas P. Johnson; Mr. George D. Lockhart; Mr. and Mrs. J. Sherman McLaughlin; Mrs. Emily F. Oliver; Mr. Sherman Parker; Justice and Mrs. Thomas W. Pomeroy, Jr.; Mr. and Mrs. William H. Rea; Mr. William M. Robinson; Mr. John P. Roche; Mr. John T. Ryan; Mr. and Mrs. Roger B. Sutton; Mr. and Mrs. James M. Walton; Mrs. John F. Walton; Mr. Mason Walsh, Jr.; and Mr. and Mrs. James L. Winokur.

PHILLIP M. JOHNSTON
Director
The Carnegie Museum of Art

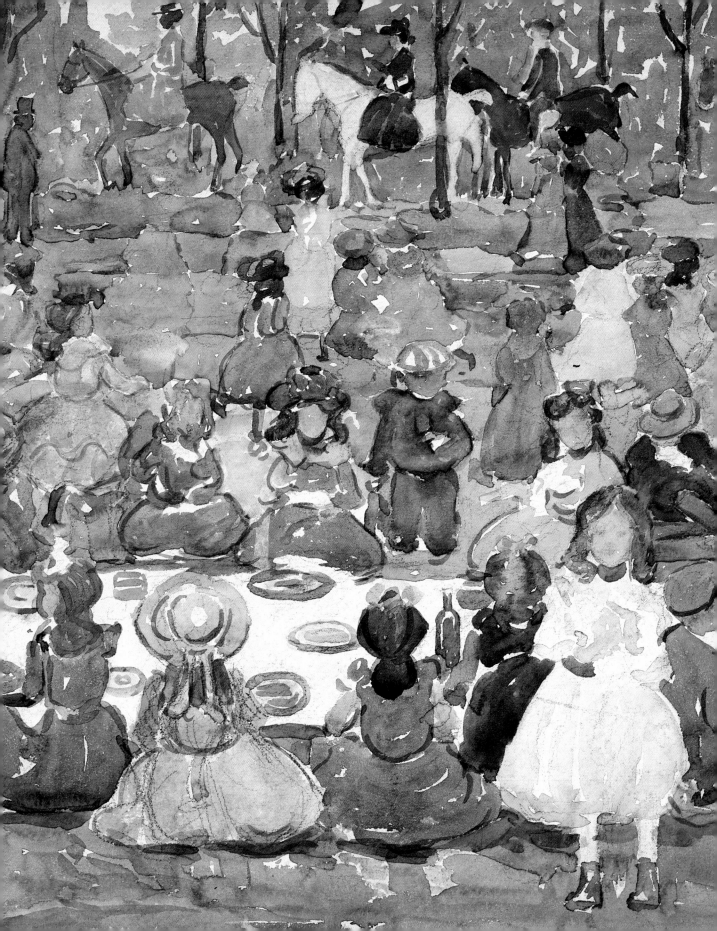

The Beal Collection

Mrs. Beal was old when I knew her, and her husband was in poor health. A visit to Carnegie Institute was a monumental exercise, in part because her memory was beginning to fail and she could be scattered and forgetful, but also because she was afraid, even for a moment, to leave her husband. Arranging for her to make the trek a few hundred yards down Craig Street to the Museum was like mounting an expedition to the North Pole. Often, after elaborate plans had been made and schedules changed and rechanged to suit her fluctuating needs, she would cancel at the last minute — some small crisis had occurred.

Consequently, once she had grown to know me, it was easier to forego ceremony or the trouble of inviting her out to lunch and to meet her in her apartment on the sixth floor of the Park Plaza. These meetings also required detailed planning, through phone calls or even notes and letters, for as she grew older she had grown suspicious of visitors. Still, it was less stressful than getting her to the Museum and also more interesting. Not that the Beals lived in grand style. For the most part, the setting was extremely modest; that was part of what was so intriguing and curious about them.

My contact with Mr. Beal was limited. He must have been a quiet fellow — as a lawyer I'm sure he was valued for his ability to hold other people's secrets — but when I knew him his silence was nearly complete because he had suffered a severe stroke and could hardly talk. Voicing a simple sentence was an enormous effort for him. Generally when I visited he sat stiffly upright in his chair, almost immobile, and so far as I ever witnessed, never complained. When I arrived at their apartment he would often struggle to his feet

MAURICE BRAZIL PRENDERGAST
The Picnic (detail), 1901
(cat. no. 71)

11

Mr. and Mrs. James H. Beal, c. 1980

to welcome me. (As Leon Arkus recalled, "After his stroke, that man would not be put down by anything.") Mr. Beal had a gentle face, which had frozen into a kindly smile, and I sensed that he was a sweet-tempered man. Mrs. Beal's devotion to him was total. He was probably the only thing she valued more than art.

I can hardly remember their apartment, which had little to distinguish it and was not so different from where I was living, also on Craig Street, on the salary of a beginning curator. The walls were white, and the furniture, some of which was old but none truly grand or distinctive, was mostly plain, unpainted wood. There were books in good number, if not in profusion. But, because they were not finely bound nor in any particular order, and because Mrs. Beal was always at my elbow and it was hardly polite to indulge my propensity to browse, it was not until after their deaths that I learned that a number of their books were unusual and rare—for instance, an early printing of Walt Whitman's *Leaves of Grass*, illustrated with etchings by John Sloan, and several first editions of Edwin Arlington Robinson. These volumes, had I noticed them, would have provided clues to the Beals' unconventional taste and to their special areas of interest.

At the time, however, only the art on the walls stood out as

remarkable, and even the art had a rather unassuming presence, since what attracted the Beals was inner spiritual resonance rather than large size or strong decorative impact. It always took me a while to adjust to the fact that two of the watercolors in the living room were by Edward Hopper and that they ranked with the best Hopper watercolors I had ever seen; and that the work hanging beside them was a Charles Demuth still life, as delicate as any of his paintings.

Admittedly, these were some of their finest possessions. Not all the other paintings—there were works by Arthur Dove and Charles Burchfield, as well as other Hoppers and Demuths—were at that same top level; but they were all surprising and daring things to have stumbled on in such a modest setting and all the more touching because of the obvious love with which they had been acquired. For in a quiet way, without fuss or drawing attention to themselves and on a budget that by today's terms seems ridiculously modest, the Beals had put together one of the finest art collections in Pittsburgh.

It was the art collection that brought me in contact with the Beals, specifically their collection of watercolors by Charles Demuth. The Museum was receiving a travelling show of Demuth's work, and Mrs. Beal generously agreed to supplement the exhibition with the Demuths she had collected.[1] She had fully a dozen of them, most of which, admittedly, were of modest size and artistic scope. Initially, the idea was simply to display the works, but the project grew as I learned more about what she owned. It turned out that several works were unpublished and unphotographed; that several of them marked an important or unusual aspect of Demuth's work; that many of them had been purchased from Robert Locher, Demuth's friend and heir; and that careful records relating to every work had been kept. Before long I was hard at work writing a full description of the Beals' collection of Demuths, a project that consisted mostly of organizing the material that Mrs. Beal provided.

She had a hard time finding things: every time she opened a bureau drawer it proved to be filled with little scraps of paper covered with mysterious notes and organized according to a system that made sense only to herself. However, she had a Chinese scholar-collector's interest in marks, inscriptions, seals, exhibition history, and provenance; in the end she turned up everything one could have wished to know about each example—its previous ownership, where

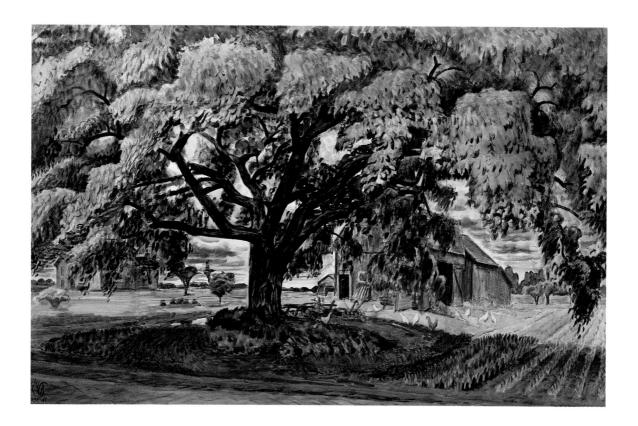

1. CHARLES E. BURCHFIELD
The Great Elm, 1939–41
Acquired in 1944.

*Note: essay illustrations
are arranged by date of the
Beals' acquisition.*

it had been shown, and the exact date of purchase. In many cases she had recorded when she first saw a work, if she had spotted it in an exhibition before tracking it down to a dealer. She even kept the cancelled checks, drawn on Mellon Bank, that she had written to art dealers and had neatly filed in the appropriate folder.

While modestly conceived, the Demuth project became increasingly time consuming and demanding, in part because every step of the process required elaborate negotiation and discussion with Mrs. Beal. Transferring the works to the Museum, having them photographed, putting the documentation in order, corresponding with other scholars, and producing a "catalogue" for *Carnegie Magazine* all required a good deal of effort. But the adventure was well worth it, bringing personal dividends that went far beyond the actual product. By the time I had finished, Charles Demuth felt like a friend.[2]

How did the Beal collection get started? Was it Becky or Jim Beal who played the principal role? What inspired a conserva-

tive couple from Pittsburgh to become avid collectors of artists like Charles Demuth and Arthur Dove, who, at the time the Beals began collecting in the 1940s, must have been incomprehensible to most of their friends? (As Leon Arkus said of Mrs. Beal: "Her early interest in Dove, Demuth, and those people — really the Stieglitz group — was quite ahead of her time.") I asked myself these questions when I met the Beals, but at the time it was difficult to make much progress toward answering them.

For one thing, it was hard to form an overview of the Beals' collection. Though they had already made impressive donations to the Museum of Art, many of their best works were still at home, not only on the walls but also tucked away in drawers and closets. From time to time a previously unknown piece would emerge from some dark place as another gift to the Museum, raising my curiosity about what else might be quietly hiding. Given this incomplete picture of their holdings, it was not easy to gain a clear sense of the range of their taste or the distinctive nature of their collecting focus.

In addition, Mr. and Mrs. Beal shared an almost pathological distaste of publicity; they considered it vulgar. So they avoided any sort of boasting or even discussion of what they had collected. Although a painting by Edward Hopper hung in Mr. Beal's office for many years, he never drew attention to its importance; and despite regular donations to the Museum and his service there on the Board, most of Jim Beal's business associates seem to have been unaware of his artistic interests. James Walton, former president of Carnegie Institute, recalled that "nobody ever knew he had a big collection or anything like that. He never made mention of it — never flashed it about."

The Beals also hated any discussion of money. In an amusing letter to Gustave von Groschwitz, the director of the Museum of Art, whom she addressed as "Von," Mrs. Beal made it clear that any mention of money was off limits. As she wrote, in her curiously definite way: "I disliked an announcement once made at a Women's Committee meeting some time back when the value of the gift was announced. It is not necessary for the value of the gifts to be announced publicly. They merely need to be recorded."

Only since their deaths have I had access to documents that charted the growth of their collection: Mrs. Beal's detailed notes

15

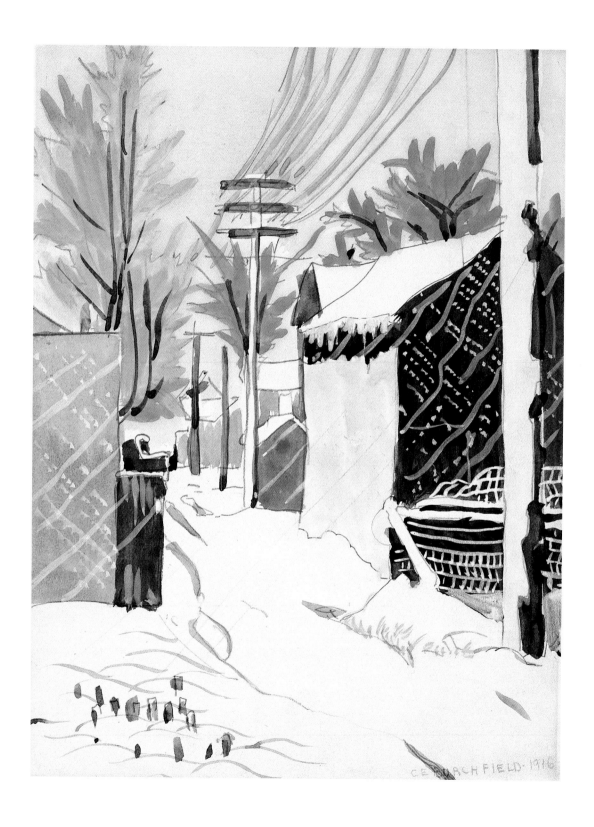

about when and where she discovered and purchased works of art, notes that itemize the full range of what the Beals collected, and obituary notices that provided the basic outlines of their lives. This evidence, however, is often frustratingly incomplete, like a puzzle with missing pieces in the center, consisting as it does mostly of dry facts such as dates, places, and prices.

Regrettably, Mrs. Beal left little narrative expression of her personal feelings, motives, or goals. Although she had a sharp intelligence and wit, she was never given to gushing, nor did she like to write long passages of expository prose. (For her book on Jacob Eichholtz, for which she did all the research, she asked E. P. Richardson to write the introduction describing the life of the artist.) Consequently, the goals the Beals set for themselves and the curiously original vision that motivated them must, for the most part, be deduced from seemingly unpromising materials.

The very thought that after their deaths a relative stranger would scrutinize what they had paid for works of art would probably have offended the Beals, who liked to keep all such financial considerations out of view. But, as there is no other way of tracing what they did, the purchase records must suffice. In fact, when we gather the evidence, definite patterns begin to emerge; we even have the beginnings of a story. This story can be filled in, moreover, with the memories of a few people who knew the Beals and with a few revealing passages—comments made in passing—in Mrs. Beal's letters. These different sources produce at least a dim picture of what the Beals did and of their motives, although many mysteries remain.

MR. AND MRS. BEAL

Mr. Beal died on February 14, 1987, two years after I left Pittsburgh. An obituary composed not long afterwards by Ralph Demmler, his colleague at Reed Smith Shaw & McClay, provides the outlines of his career in the law as well as his father's.[3] Father and son totalled eighty-eight years of almost continuous service in the same law firm, but they had markedly different temperaments and approaches to litigation.

Mr. Beal's father was a brilliant and energetic trial attorney, who handled a mind-boggling load of cases. He spent his weeks

2. CHARLES E. BURCHFIELD
Snow-Covered Alley, 1916
Acquired in 1945.

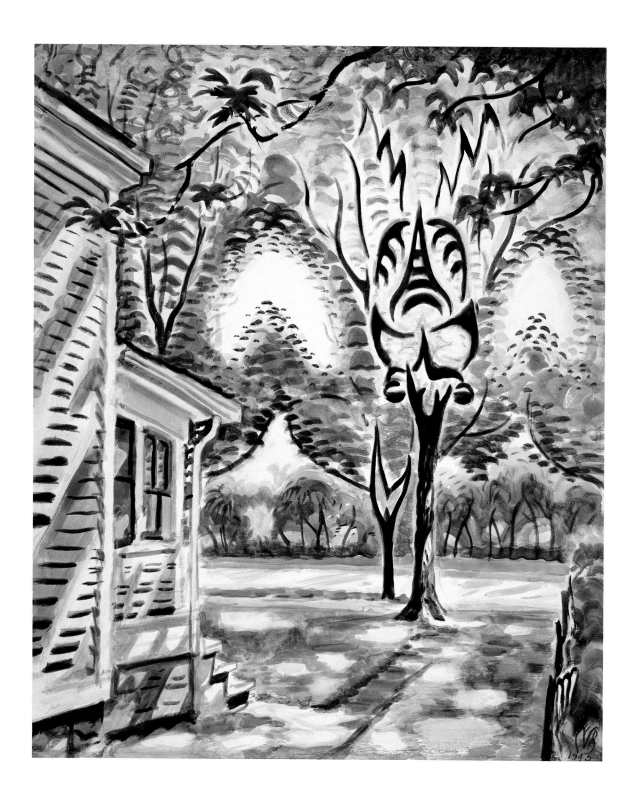

rushing back and forth between the Superior Court and the Supreme Court, where he often had several cases proceeding simultaneously. He devoted his weekends to dictating briefs, one after another, to a battery of stenographers. In what time was left over, he provided counsel on tax law and was often called to Washington, D.C., to advise Andrew Mellon. Evidently the stress became too much for him, for he died of a heart attack in 1922 at the early age of fifty-two.

James Beal, Sr., must have been a hard act to follow; James Beal, Jr.'s, career, while equally outstanding, followed a different path. Mr. Beal's nephew Joseph Van Buskirk said of his uncle: "He was almost the opposite of your usual picture of a lawyer. Jim Beal would not have made a good criminal lawyer. He was not the kind of guy to go into a courtroom and ask tricky questions. He had a gift for compromise, for getting something accomplished by bringing people together—not by pressing his own point of view."

Jim Beal did not respond well to great stress; indeed, he had extremely delicate nerves. Leon Arkus, who was director of the Museum of Art from 1968 to 1980, recalled going with him to an auction at Sotheby's to bid on a painting by John Kane. Mr. Beal had never been to an auction before; when the bidding became intense he became flushed, broke into a sweat, and lost his voice. He was genuinely paralyzed by excitement when Arkus landed the painting, just a few dollars under his top limit.

Yet Jim Beal's career was as distinguished as his father's, though in other ways. Born in Pittsburgh on August 28, 1898, Jim Beal attended The Hill School in Pottstown, Pennsylvania, served in the U. S. Navy during World War I, earned his undergraduate diploma at Princeton University in 1920, and received his law degree from the University of Pittsburgh in 1928. Before entering law school he worked for the Pittsburgh Coal Company as a travelling auditor, which entailed site visits to coal mines along the Montour Railroad to establish the accuracy of the financial records. Such investigative work could be hazardous; accordingly, a gun-toting supervisor accompanied Mr. Beal on his trips.

After obtaining his degree, he joined the law firm of his late father, where he focused almost from the beginning on corporate, banking, tax, estate, and trust work, for which he showed outstanding ability. From 1942 until 1957 he served as assistant managing partner

3. CHARLES E. BURCHFIELD
 Sun Glitter, 1945
 Acquired in 1946.

19

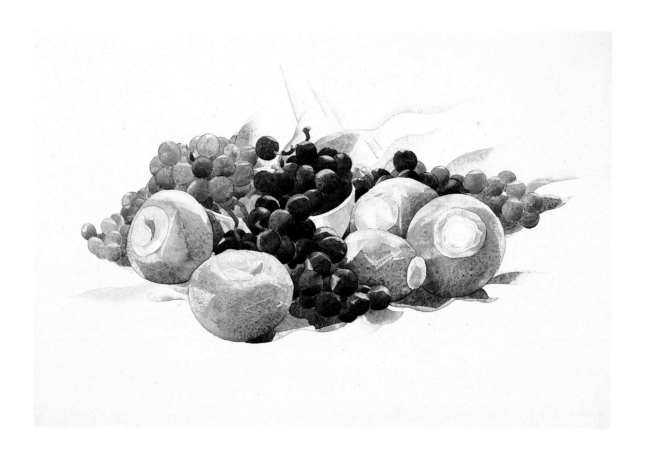

4. CHARLES DEMUTH
Grapes and Turnips, 1926
Acquired in 1947.

of his firm and as managing partner from 1957 until 1961. For a time he was head of the firm's tax group. He retired in 1968 at the age of seventy but continued to provide advice and counsel. In Mr. Beal's obituary Demmler noted that: "Integrity, careful thinking, and civility in both litigation and negotiation characterized his career throughout his professional life. He was admired and respected for both modesty and firmness."

On the side Jim Beal worked devotedly for civic causes, serving as a trustee of Carnegie Institute, Carnegie Mellon University, the Carnegie Library of Pittsburgh, the Pittsburgh Zoological Society, the Pittsburgh Association for the Improvement of the Poor, and the Historical Society of Western Pennsylvania. From 1962 until 1971 he was chairman of the Museum of Art Committee (now The Carnegie Museum of Art Board). He was a director of the Allegheny Trust Company and of the Pittsburgh Gage and Supply

Company and a member of the Duquesne Club, the Pittsburgh Golf Club, the Fox Chapel Golf Club, the Rolling Rock Club, and the Laurel Valley Golf Club.

Leon Arkus remembered that, "The way he conducted meetings and any affairs of the Museum was always thoughtful and considerate of others. But I will say this about Jim Beal: if you made your point, and he saw you were really serious about the matter, you could be assured of his backing. He would not tolerate any nonsense — any small actions or anything of that nature. He had a strong sense of ethics. If a work came in a day after the new year he wasn't willing to change the date. While he was a detail man, he had a strong sense of integrity. I keep coming back to that word. That was his crowning quality."

Those who knew Jim Beal in his prime speak of him with affection and reverence. James Walton remembered him as "a wonderful, gentle, very wise man. He helped me a lot. He was a kind of father figure to me." Remarkably, Joseph Van Buskirk described him not only in the same way but often with the very same words. "He was a gentle, loyal-to-a-fault kind of person," Van Buskirk recalled, "a reflective, wise, gentle man. My father died young, and Mr. Beal became like another father to me. You just don't meet many people like Jim Beal in your life. It isn't only I who would say that."

Mr. Beal played a secondary role to his wife in their collecting activities, but he nonetheless acquired considerable knowledge and an acute sensitivity to issues of artistic quality. His careful judgment is well illustrated by the case of a drawing by Pierre Bonnard that the Museum purchased when Mr. Beal was chairman of the Board. New York art dealer Peter Dietsch had staged a show of Bonnard's drawings; Leon Arkus, during a hurried trip to the city, ran quickly through Dietsch's exhibition and picked out a drawing before rushing off to the airport. Shortly afterwards Mr. Beal came by the gallery. Unaware that Arkus had just been there, he spent about an hour carefully going through the show, intently scrutinizing the drawings one by one. When he was finally through he went over to Peter Dietsch and said, "I think you should call Leon's attention to that picture." It was, in fact, the very drawing that Arkus had selected.

With characteristic modesty, Mr. Beal enjoyed telling this story against himself, to show how slowly he worked compared to a

trained art professional like Arkus. Yet it also illustrates the acuteness of his judgment, which was as accurate in artistic matters as it was in legal affairs.

Mrs. Beal was fiercely loyal to "my Jim" and insisted that he be given credit as an equal partner whenever they gave something to a museum or lent a piece to an exhibition. I can almost hear the annoyance in her letter of May 4, 1971, to Herdis Bull Teilman, assistant to the director of the Museum of Art, in which she objected that correspondence had been addressed "to me only," making it clear that "of course the loan will be credited to Mr. and Mrs. Beal." There can be little question, however, that Mrs. Beal was the driving force in their art activities.

Mrs. Beal, born Rebecca Huebley Jones on December 21, 1898, also grew up in Pittsburgh. Her father, Joseph Jones, owned a large toy store on the North Side, about where Allegheny Center now stands, which lasted until the Depression, when it went bankrupt. The Joneses' home was across the river in Shadyside. Shortly before she married Mr. Beal, Becky Jones was badly injured in an automobile accident, which gave her back trouble for the next thirty years. Joseph Van Buskirk remembers Mrs. Beal as "an intelligent, brainy person," who "got the two of them interested in the field of art."

While Mr. Beal was remarkably circumspect and considerate, Mrs. Beal was often brutally direct. "She had a very acidic sense of humor—it could be devastating," Leon Arkus recalled. She was extremely fond of the assistant director at the Museum, John O'Connor, and not long after Arkus arrived she bluntly told him that he would never be able to fill O'Connor's shoes. "That's right, Becky, I have my own size," Leon shot back, but the comment clearly rankled.

For all that, when Mrs. Beal believed in something she was both fearless and loyal. "The Beals—you could count on them," Arkus remembered. "Becky gave me a lot of help. I once asked the Women's Committee to help purchase an important painting by Prendergast that had belonged to the famous collector John Quinn. Well, I never took so much flak. Becky was tremendously helpful in convincing people that it was a worthwhile work.

"Another time she helped me was with the O'Keeffe. I had been given money specifically to purchase an O'Keeffe, but it wasn't enough. I finally managed to find *Gate of Adobe Church* (1929), but

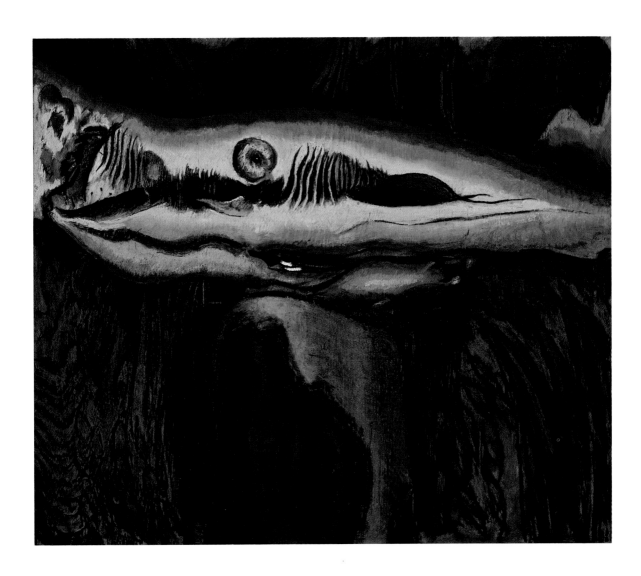

5. ARTHUR G. DOVE
Tree Forms, c. 1928
Acquired in 1947.

everyone wanted a flower painting, which I couldn't afford. It was
Becky who came to my aid and pointed out that it was a lot more
interesting as a picture than the flower studies.

"When Henry Oliver died — he was one of my favorite
trustees — we found a painting by Augustus Vincent Tack as a memo-
rial. An abstraction. I was under fire again. No one understood it,
and no one had ever heard of Tack. It was Becky again who came to
my rescue."

How did Mrs. Beal become interested in art? How did she
start as a collector? As I've noted, Mrs. Beal made few statements

23

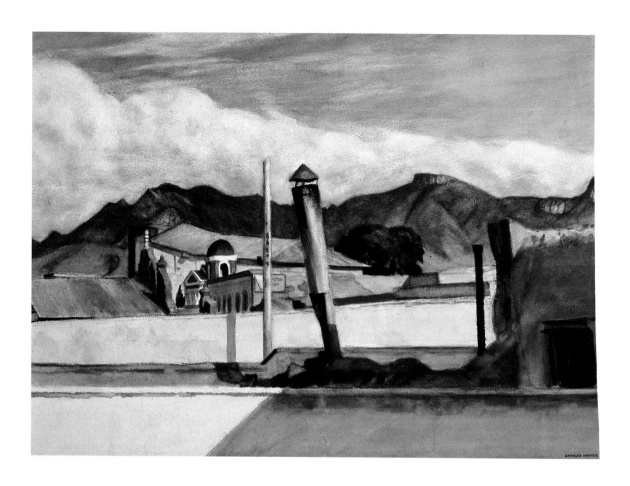

6. EDWARD HOPPER
Saltillo Rooftops, 1943
Acquired in 1947.

about her collecting, but she expressed the gist of the matter in a brief letter to me in 1984 in which she apologized for not possessing precise information about two drawings she had just donated. "Perhaps I can be forgiven," she wrote, in what is perhaps her fullest comment about her interest in art, "for the many sins of being an art idiot! I was working hard on Jacob Eichholtz at the Frick Library, and on short-time, late in the afternoons, I gobbled up what art I could see — this went on for some years! Solo. Besides that I was a student of water-color or drawing — never kept books properly."

This is cryptic, excessively modest, and not in chronological order, but it jibes with what I have pieced together from other evidence. Apparently Mrs. Beal's involvement in art began quite early; the proficiency in watercolor that she developed in her art classes at

24

Carnegie Institute encouraged her interest. Throughout her collecting career, while she acquired some oils, she was particularly interested in watercolors.

As it happens, this has always been one of the best media for American artists. Until the late 1940s, few American oil paintings ranked with the best European work; but in watercolor, American artists, beginning with Winslow Homer, struck off in an original direction. By combining the English fondness for watercolor with the French interest in bold form, spontaneous technique, and brilliant color, they achieved new effects that have little parallel in either England or France. Watercolor is the one medium in which a series of American masters — Winslow Homer, Maurice Prendergast, Charles Demuth, Edward Hopper, and Charles Burchfield — did work as good as anything in Europe. Mrs. Beal's interest in watercolor led her to collect the work of all these artists.

Mrs. Beal's collecting activity, however, might not have developed so richly without a stimulus, namely her involvement with art history. Her serious phase of collecting was of quite specific duration and was intimately intertwined with a remarkable research project — her monograph on the portrait painter Jacob Eichholtz. Her main activity as a collector occurred between the early 1940s and the early 1960s — just the period when she was most actively involved with her Eichholtz book.

Jacob Eichholtz (1776–1842) was Mrs. Beal's great-grandfather. Largely self-taught, he was not a particularly imaginative painter, and he worked outside the mainstream in the provincial town of Lancaster, Pennsylvania. Despite his limited exposure to important works of art, he produced solid, well-crafted likenesses, and over the course of his career developed an increasing skill in the presentation of psychology and character. Mrs. Beal believed strongly in the value of his accomplishment and insisted that he deserved a book. E. P. Richardson, then director of the Detroit Institute of Arts (who had said a few kind words about Eichholtz in his published survey of American art), encouraged Mrs. Beal to take on the project, no doubt in part to stop her from pressuring him to do it.

Once she got started, Mrs. Beal left no stone unturned. She combed old sales catalogues and dealers' records to find mentions of paintings by Eichholtz; she located works in private collections and

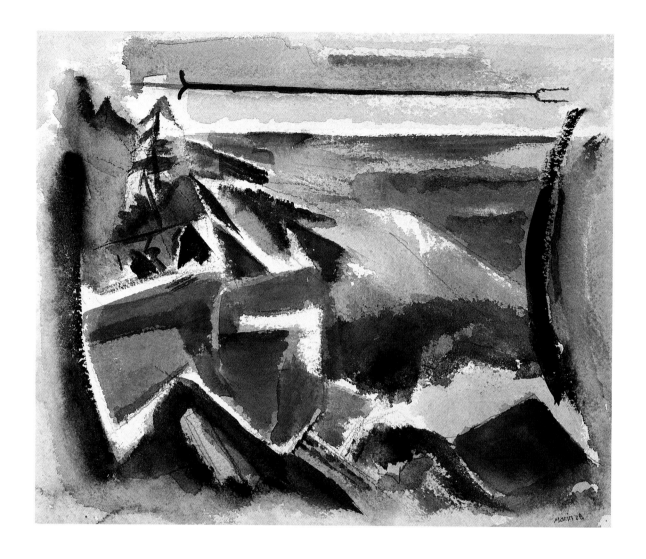

7. John Marin
 Sea Piece No. 21, Small Point, Maine,
 1928
 Acquired in 1947.

8. Charles Demuth
 Architecture, 1918
 Acquired in 1948.

others that were stored in small historical societies or lying neglected in the dusty basements of museums; she dragged virtually every painting she discovered to the conservator at the Pennsylvania Academy of the Fine Arts, Theodor Siegl, to be x-rayed and examined from the standpoint of technique; and she compiled biographies of each sitter based on original research in archival documents.

This project was exhausting not only to her but to many of those around her. "I heard about that project forever," one acquaintance commented; and Leon Arkus reflected, "That room she used as an office was without doubt the messiest room I have ever seen. Becky was always screaming that she couldn't find this or that. I don't know how many secretaries she had while she was working on that book — they followed in quick succession." Once her research was complete, Mrs. Beal persuaded E. P. Richardson to produce a short biographical essay to introduce her exhaustive catalogue of paintings. The final monograph set a standard for intensive research that has probably never been matched in the field of American art history.[4]

Jacob Eichholtz 1776–1842: Portrait Painter of Pennsylvania, which was finally published in 1969, occupied her for some thirty years. While working on it she made frequent trips east to Lancaster as well as to Philadelphia and New York. In Lancaster she became friendly with Robert Locher and Charles Weyand, the heirs of the painter Charles Demuth. In New York she did research in the Frick Art Reference Library, which was only ten or fifteen minutes from the cluster of art dealers around 57th Street. The Frick closed at four o'clock, which left an hour or so to rush over to the art dealers, for example to the Rehn Gallery, which was only a few blocks away.

During this period the Beals also had a small cottage at Boothbay Harbor, Maine, where they stayed for several weeks every summer. Mr. Beal kept a boat and enjoyed sailing; Mrs. Beal studied watercolor in Ogunquit with Elliot O'Hara, an accomplished technician. She even bought a painting by O'Hara, although more out of courtesy to him than belief in its artistic worth. "I suppose he was technically very good," she once confided to me in a tone that made it clear that she understood his limitations. The Beals' love of Maine inspired Mrs. Beal to acquire scenes of sailing and the Maine coast by artists such as Winslow Homer, John Marin, Edward Hopper, and Andrew Wyeth.

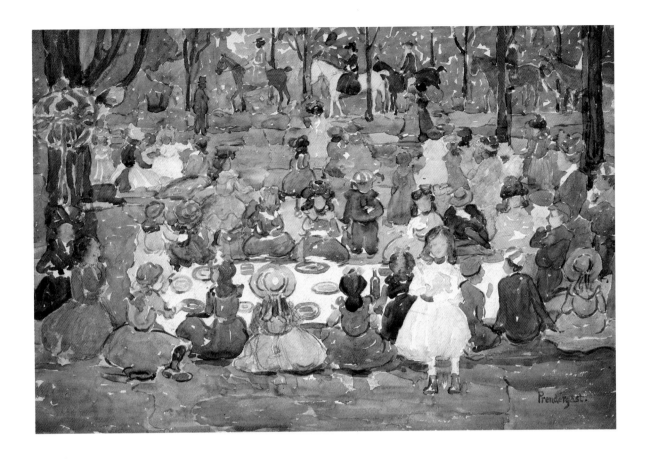

9. MAURICE BRAZIL PRENDERGAST
The Picnic, 1901
Acquired in 1949.

In general Mrs. Beal did not acquire works of art from the most fashionable and prestigious dealers, such as Colnaghi or Knoedler, but from smaller galleries in the neighborhood of 57th Street, which in some cases doubled as bookstores, and which put on small shows of worthy artists. She liked to support artists who were alive and struggling. Her favorite dealer was without question Frank K. M. Rehn, then nearing the end of his career but still in many ways the most interesting dealer of American art in New York. By present-day standards, Rehn's operation was ridiculously modest; he focused mostly on drawings and watercolors, putting on shows of a dozen or two dozen works, with catalogues consisting of a single, folded printed page. Rehn's eye for quality, however, was unsurpassed, and he was largely responsible for discovering and engineering the careers of two giants of American art, Charles Burchfield and Edward Hopper. Mrs. Beal also purchased from Kraushaar Galleries, Wehye Gallery,

Maynard Walker Gallery, and the Downtown Gallery, where she seems to have preferred to deal not with Edith Halpert, whose hard-sell tactics evidently put her off, but with Halpert's assistant, Charles Alan.

The four major artists whose work Mrs. Beal particularly loved, and which she acquired in multiple examples, were Charles Burchfield, Charles Demuth, Edward Hopper, and Arthur Dove. She purchased work by all of these men within her first four or five years of collecting and continued to focus on them, to the extent that she could afford it, until she stopped serious collecting soon after 1960.

CHARLES BURCHFIELD

Most of the artists that Mrs. Beal collected she was unable to meet personally: Demuth was already dead, Dove died in 1946 just as she was getting started, and Hopper was misanthropic and unsociable. But she did establish a personal relationship with Charles Burchfield.

In photographs Charles Burchfield looks like the family dentist rather than a painter of visionary fantasies. He spent his life in small towns, such as Salem, Ohio, and Gardenville, New York. Outwardly his career followed a steady, uneventful course: he married, raised a family, worried about money, and died of a heart attack at the age of seventy-three. Behind his sedate facade, however, his mind was filled with exuberant, almost psychedelic fantasies that poured out with unceasing productivity into his paintings: everyday scenes that to other eyes might seem dull or ugly took on an almost religious intensity. At an early date Mrs. Beal fell in love with his work, and her enthusiasm never wavered.

The roots of Mrs. Beal's zeal for Burchfield were apparently established in Pittsburgh, even before she began work on her Eichholtz monograph. She once told me that she had come to admire Burchfield from seeing his work at the Carnegie Internationals, where he had already exhibited ten times by 1944. Although none of his works were purchased by the Museum, Burchfield won second prize at the *International Exhibition of Paintings* in 1936 and was honored with a one-man show at the Museum in 1938, during the course of which he became acquainted with Mrs. Beal's friend, the

assistant director John O'Connor. Part of what must have appealed to Mrs. Beal, who was herself a watercolor painter, was that Burchfield was the only watercolorist who regularly showed at the Museum. At the Internationals the scale and quality of Burchfield's works made a striking statement: they asserted that a great water-color can reach the same artistic heights as a great oil.

Mrs. Beal bought most of her Burchfields from Frank Rehn, who had played a significant role in making possible Burchfield's artistic career. Rehn did not discover Burchfield, for before he repre-sented him Burchfield's work had been handled by the Sunwise Turn Bookstore in New York and later by the Montross Gallery. These dealers, however, priced Burchfield's work so low and sold so little of it that he was unable to support himself by painting. As a conse-quence, to earn a living Burchfield was obliged to work at routine commercial jobs, first in the cost department of a small manufacturer in Salem, Ohio, and later as a wallpaper designer for H. H. Birge and Sons in Buffalo, New York.

Frank Rehn learned of this situation and wrote to Burchfield in 1928 with an offer to represent him. Burchfield could not make up his mind, nor was Montross willing to share him with another dealer. Fortunately, the impasse was broken when Edward Root, a collector and professor of art at Hamilton College, arranged a meet-ing between Rehn and Burchfield at his home in Clinton, New York. At Root's urging Burchfield shifted to Rehn, and within a month of this decision sales were so encouraging that Burchfield abandoned his job designing wallpaper and began to paint full time. Thus, it was largely thanks to Frank Rehn that Charles Burchfield became a full-time artist.[5]

While I have no direct evidence, I am fairly confident that it was her admiration for Burchfield that brought Mrs. Beal and Frank Rehn together. I can almost see her going up to him, expressing her enthusiasm for Burchfield's work, and their friendship instantly blossoming.

So far as I can make out, Mrs. Beal's first substantial art pur-chase was a watercolor by Charles Burchfield, *Winter Rain from the East* (1940), which she purchased from Rehn in November 1941. She and Mr. Beal donated it to The Art Museum, Princeton Univer-sity, in 1962.

Three years later, in 1944, Mrs. Beal purchased another Burchfield watercolor from Frank Rehn, *The Great Elm* (cat. no. 21), an extremely large and imposing work, which she donated to Carnegie Institute the same year. Always a fighter for what she believed in (this donation was obviously intended to boost Burchfield's reputation), she wanted his work to be collected and displayed in an important American museum. This was one of the most expensive purchases of her collecting career. She paid two thousand dollars for the piece.

Burchfield had likely heard about Mrs. Beal from Frank Rehn, but they had never communicated. On December 7, 1944, soon after her purchase of *The Great Elm*, Burchfield wrote to her to express his gratitude. "I have just heard the thrilling news that my 'Great Elm' has gone into the permanent collection of the Carnegie Institute, and that you are responsible and have supplied the means." He followed with a careful description of the subject and concluded by offering to show it to her. "If we ever may have the pleasure of a visit from you here in Gardenville, I should love to take you out there (it is only six miles from our home) and let you stand under it. It is an experience almost as potent as Niagara Falls." [6]

In the same letter, Burchfield described the earlier watercolor Mrs. Beal had acquired. "It has always pleased me that you bought the 'Winter Rain from the East'," he wrote.

> The scene is one I see from my bedroom window. The poplar tree belongs to my neighbor, but is so close to our house that I feel it belongs to me. It is a very friendly thing to have just outside one's window. He planted four of them, some time ago. One day several years ago I came home from a trip to town, and was horrified to discover he had cut one of them down and was preparing to start on the next one. I asked him what on earth he thought he was doing (it never occurred to me that they were his trees) and he said he thought they were obstructing our view and that he'd better cut them down before we protested! So I saved the other three, but the one he cut had the same relation as 'mine' to my daughter's window and it was many days before she could get over the loss of 'her' tree.

This marked the beginning of a relationship that was pursued through notes, Christmas cards, and occasional meetings until the artist's death in 1967. Moreover, Burchfield's first letter seems to

10. CHARLES SHEELER
 Thundershower, 1948
 Acquired in 1949.

have had a stimulating effect, for shortly after receiving it Mrs. Beal began energetically acquiring works not only by Burchfield but also by other notable American artists.

For the next few years she went on what might be termed a Burchfield binge: by 1948 she had purchased four more of his works from Frank Rehn — *Snow-Covered Alley* (cat. no. 9); *Railroad at Night* (cat. no. 15); *Wires Down* (cat. no. 16); and *Sun Glitter* (cat. no. 24) — as well as one from Antoinette Kraushaar, *Crow and Pool* (cat. no. 14). A five-year hiatus in Burchfield buying followed, like a pause to digest after gluttonous eating. In 1953 she went to Cleveland to see an exhibition of Burchfield's drawings put on by the Print Club of Cleveland at the Cleveland Museum of Art. The prices were low and she loved drawings, so she snapped up ten, many of them early works, for prices ranging from $35 to $80, making out her

checks directly to the artist. If my memory serves me correctly, she told me that on this trip she made a detour from Cleveland to Gardenville where she visited Burchfield in his studio.

She purchased her last Burchfield, the haunting watercolor *Moon Through Young Sunflowers* (cat. no. 8) in 1956 from the Rehn Gallery, working through Rehn's associate and successor, John Clancy. One could argue that this last Burchfield acquisition was her best. Certainly, *Moon Through Young Sunflowers* has been more widely published and exhibited than any of the other Burchfields she owned.

Burchfield was the first artist to whom Mrs. Beal committed herself. His work combines many of the things she liked best: he was a watercolorist; his work dealt with simple, regional things of a sort that most people would consider ugly; he combined this interest in the ordinary, in what we see everyday, with a mystical, spiritual, almost religious quality; his work was not decorative, flashy, or technically flamboyant; and it was based on an almost naive sincerity.

While Mrs. Beal purchased works individually, not according to a definite plan, her taste did grow more sophisticated. She began by acquiring Burchfield's more realistic paintings, such as *The Great Elm*, and went on to obtain the more visionary works of his early and later periods. Her last purchase, *Moon Through Young Sunflowers*, was not only arguably her best, but her most adventurous: the painting has the mystical, abstract quality found in the avant-garde work of Arthur Dove.

CHARLES DEMUTH

The artist Mrs. Beal pursued over the longest time and through the greatest number of dealers was Charles Demuth, whose watercolors she purchased from 1947 until 1960, eventually assembling a group of a dozen works. Demuth held a special fascination for her because he had worked in Lancaster, Pennsylvania, and his heritage overlapped in many ways with that of Jacob Eichholtz, Mrs. Beal's great-grandfather. Eichholtz and Demuth weren't blood relations, but something close: Eichholtz had painted a shop sign, which still exists, for the residence in which Charles Demuth grew up, and Eichholtz's daughter married into the Demuth family. Eichholtz and

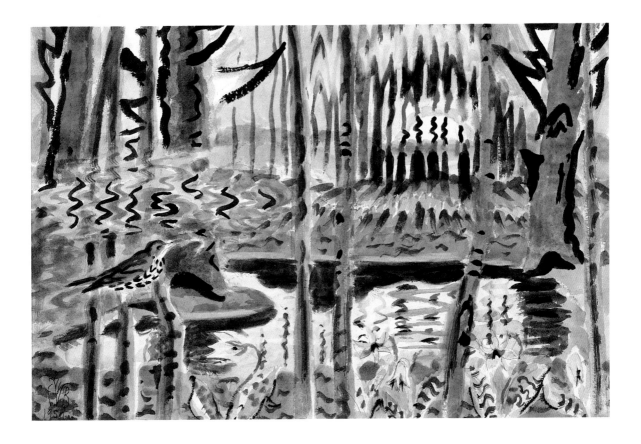

11. CHARLES E. BURCHFIELD
Song of the Wood Thrush, 1950
Acquired in 1951.

Demuth were the two notable artists of Lancaster. For Mrs. Beal, Demuth was a kind of honorary member of her family.

When Mrs. Beal was in Lancaster doing research for her Eichholtz book, she frequently visited Demuth's heirs, Robert Locher and Richard Weyand, at the former home of the artist; and she frequently dined with them at Stevens House, a Lancaster hotel. Seven of her twelve Demuths came in one way or another from Locher or Weyand: four were directly purchased from them, one was a Christmas gift from Robert Locher, and two came from dealers (Durlacher and Kraushaar) with whom the heirs had consigned works.

Mrs. Beal's close relationship with Locher and Weyand is apparent from a chatty note of May 27, 1950, that Locher sent to her in Boothbay Harbor. In it he apologized for having been slow in sending her a watercolor, *Two Figures: Turkish Bath* (cat. no. 29), that she had purchased from him. Locher wrote:

12. LYONEL FEININGER
Luminosity, 1948
Acquired in 1950.

My Dear Becky: I am ashamed that the enclosed has been sitting right here for all these days instead of being sent promptly back to you with many, many thanks and all my wishes that you enjoy the witty number that it is. . . The rainy spring has caused the garden to be lush but out of hand and ill groomed. . . every time that we had time to give [to] it the heavens would open up again. . . I am depressed at its weediness. . . perhaps a pleasant weekend will come and it may get back into condition with two days of intensive care. . . A picture post card of a sailing ship in a spanking breeze would cheer us up no end. So long. . . bless you, Becky dear, and thanks again.

Mrs. Beal's other Demuths came from the Downtown Gallery, Edwin P. Hewitt, Frank Rehn, Maynard Walker, and as a gift from Edgar J. Kaufmann, Jr., to Mr. Beal.

It did not take long for dealers to learn that she found it difficult to resist a new Demuth. On June 7, 1949, for example, she received a letter from Charles Alan at the Downtown Gallery:

Today we are shipping the Doves. I had them put in identical frames

so that you may hang them in any combination. Along with them I had shipped two vaudeville Demuths. I thought I might as well tempt you. The smaller is one Mrs. Halpert recently acquired and had not planned selling so soon. The other is one we have had for some time, and is one that Mrs. Halpert considers the finest of the early circus and vaudeville watercolors. Choice and very rare. It has much the quality of "The Turn of the Screw" illustrations in its design and color. I am curious about your reaction to them. One of these two should certainly complete your collection of Demuth. As these paintings belong to the gallery, and there is no living artist involved, there is no great rush about paying for them.

Evidently, Mrs. Beal did not like to be pressured, as she returned both works. But she did not stop purchasing works by Demuth, even though they were already becoming quite expensive. For example, *White Horse* (cat. no. 27), which she purchased in 1951 from Richard Weyand, cost $1,000, nearly as much as she paid for each of her two best Hopper watercolors. Such prices were clearly a stretch for Mrs. Beal, and it took her from November 6, 1951, until September 23, 1952, to pay for the piece, doing so in eight installments. Similarly, when she bought Demuth's *White Lilacs* (cat. no. 35) from R. Kirk Askew, Jr., at Durlacher Brothers, she took possession of the work on June 17, 1954, but did not make the first payment until September 27, when she paid $200.

By the late 1950s Mrs. Beal's letters show that while she had an insatiable hunger for more Demuths, prices were rising to a level she felt she could no longer afford. On October 9, 1957, at the time of the Parke-Bernet sale of Richard Weyand's collection, she wrote to her dealer-friend Maynard Walker:

I cannot go to the Demuth sale. Only beginning to get some pep, only now getting settled into a new cook, part-time, only now doing desk work piled up—some since winter, etc. Have just looked over the Parke-Bernet catalogue. I do not NEED any Demuths, but love them. If you care to suffer through the sale, if you happen to get any one or more of the numbers I quote I could buy from you? Once long ago I paid fifteen hundred for one, once a thousand, etc., but—.

At the auction, prices soared out of her range.[7] Not long afterwards, Maynard Walker reported back: "Prices all very high— I'll send you complete list later. . .The horrible Halpert bought Nos.

51 and 56... No. 78 went for $3,000!"

 Mrs. Beal's last Demuth purchase, a self-portrait on the beach at Provincetown, Massachusetts, was acquired in 1960. Maynard Walker had spotted it at an exhibition in Ogunquit, Maine. On July 6, 1960, he wrote describing the work:

> I can't be too accurate about color, but the figure is a nice lobster red (almost). I think his trunks are blue and the piles are browny-green-ish — very handsome — simple — something bluish in the distance, and, as you say, the most wonderful spaces left untouched — for example, the canvas before the artist — blank! And it is handsomely framed.

Painted in the last summer of Demuth's life, this was his final self-portrait and made a fitting coda to Mrs. Beal's Demuth collection.

 I confess that I am particularly fond of Mrs. Beal's Demuths — and not only because it was through this collection that I first became acquainted with her. Even the slightest of Demuth's drawings reveal his grace and accuracy of line, which not only represents the form but in a sense becomes it. Moreover, more clearly than most artists, he recognized that the handling of watercolor is really just a question of wet or dry, a seemingly simple choice that nonetheless affords infinite refinements and permutations. Without exception, Mrs. Beal's Demuths are witty, alive, and suffused with a curious emotional intensity. For the practicing watercolorist or attentive connoisseur, they are inexhaustible in their artistic lessons.

EDWARD HOPPER

 Frank Rehn represented not only Burchfield, but also Edward Hopper. Indeed, he can virtually be said to have created Hopper, as it was his enthusiastic backing that made Hopper's career possible. In 1924, when Rehn staged his first exhibition of Hopper's watercolors, the artist had sold only one painting, a small oil titled *Sailing* (cat. no. 56), which he had exhibited in the Armory Show and had sold to a certain Mr. Thomas F. Vietor, who had seen it there and had asked to acquire it. Over the course of the next ten years, Hopper was unable to sell a single picture. Rehn found out about his work, put on an exhibition of eleven watercolors, and managed to sell out the entire show as well as five more works not on display.

13. MARSDEN HARTLEY
Garmisch-Partenkirchen,
c. 1933–34
Acquired in 1951.

39

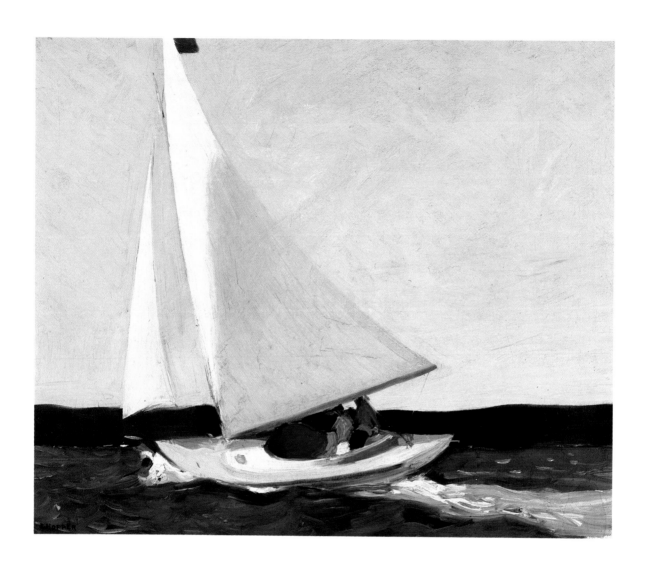

14. EDWARD HOPPER
Sailing, c. 1911
Acquired in 1952.

On the strength of this success, Hopper decided to abandon his job in advertising and devote himself full time to painting.[8]

Something about the silence of Hopper's work, its sense of quiet poetry, resonated deeply within Jim Beal's personality. (Charles Burchfield wrote of Hopper: "The element of silence that seems to pervade every one of his major works. . .can be almost deadly."[9]) Nonetheless, it seems to have been Mrs. Beal who tracked down and purchased Hopper's work, often as gifts for her husband. Between 1947 and 1954, Mrs. Beal acquired five Hoppers, all of them from Frank Rehn and all meticulously documented. It is easy to forget that at the time Mrs. Beal was purchasing Hopper's work, while he was not unknown, most people considered his paintings horrendously ugly. Once again, her taste was in advance of her time.

Her first purchase was a watercolor of a Mexican town, *Saltillo Rooftops* (cat. no. 60), which she acquired for $750, having first noted it in an exhibition in Philadelphia at the Pennsylvania Academy of the Fine Arts in 1945. In 1950 she lent it to an exhibition of Hopper's work at the Whitney Museum of American Art, and on February 16, 1950, Rehn wrote her a short note to express his gratitude, as well as his pleasure over the success of the exhibition.

> Just heard from Hopper who got in to see his show for the first time this morning. To quote his own words when I asked him how he liked it, he said, "Well, I expected to be very downcast after seeing it, but I am not." Cannot tell you how glad I am that it was a boost to his morale. Personally, I cannot see how else it possibly could be.
>
> Incidentally, when John [Clancy] and I saw the show alone the day after the opening, Lloyd Goodrich pointed to your 'Saltillo Rooftops' and said that's my favorite of any of the Mexican watercolors.

In 1952 Mrs. Beal acquired her second Hopper, a small oil titled *Sailing* — the very work already mentioned, which was the first painting the artist ever sold. Understated but deeply moving, *Sailing* is not as arresting in composition as Hopper's mature work, but equally as powerful in its mood. A lone sailboat with two figures on board cuts through the deep blue sea, leaving a white wake. The light is fading, and the coast in the background has a gray-blue hue.

Leon Arkus remembered, "Jim Beal loved one painting — his favorite was the Hopper painting, *Sailing*. That was his absolute favorite." It hung for years in his office, and he studied it daily,

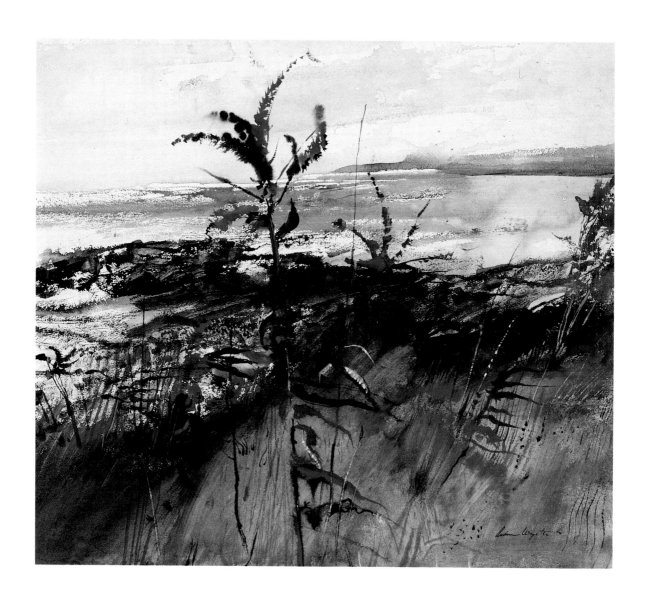

15. ANDREW WYETH
 September Sea, c. 1953
 Acquired in 1953.

combining as it did two of his greatest loves, art and sailing. It was probably the personal possession that meant the most to him, that he prized most deeply.[10] With his usual generosity, he felt he should relinquish it for the public good and donated it to the Museum of Art when the Sarah Scaife Gallery opened in 1972.

Not long afterwards, Dr. David Wilkins, a professor at the University of Pittsburgh, discovered that the sailing scene had been painted over an early self-portrait, whose outlines can be dimly discerned when the painting is viewed in raking light. Mr. Beal had never noticed this, and he enjoyed pointing out this discovery as an example of the miraculous sleuthing talents of art experts.[11]

Perhaps Mrs. Beal's greatest single coup as a collector was her purchase in April 1954 of two of Hopper's finest watercolors, *Roofs, Washington Square* (cat. no. 58), a view from the roof of his studio, and *Rock Pedestal, Portland Head* (cat. no. 59), a dramatically cropped composition showing the lighthouse off Portland, Maine. *Roofs, Washington Square* has been frequently reproduced; but *Rock Pedestal, Portland Head* is equally fine. If Hopper ever painted two better watercolors, I have not seen them. The acquisition of these two works alone would be enough to establish Mrs. Beal as a collector of significance.

In a letter of July 15, 1984, to Jack Lane, the director of the Museum of Art, Mrs. Beal noted that the purchase of these two works was "an unusually personal acquirement, approved and arranged by Frank Rehn." In fact, both watercolors came from Rehn's personal collection; Mrs. Beal first discussed buying them four years before he finally agreed to let them go. On February 6, 1950, Rehn wrote to tell Mrs. Beal that he was unwilling to sell the works, but would put her on his list of prospective buyers:

> I purchased from Hopper, as any one else could have bought them (they were not gifts in any sense) and therefore Ed neither would nor could object to my selling them at any time. I both love them, and, in my estimation this is not the time to sell them. . . Now, how about this as a solution: You pick out the one you like most and I'll promise that if, for any reason, I desire to sell it, you shall have the first opportunity; the price to be named at that time? Will that quiet that generous heart of yours? (I have the same arrangement with three people on a Burchfield I own, in the order 1, 2, 3. It has stood so, fourteen years, and I still hear from them.)

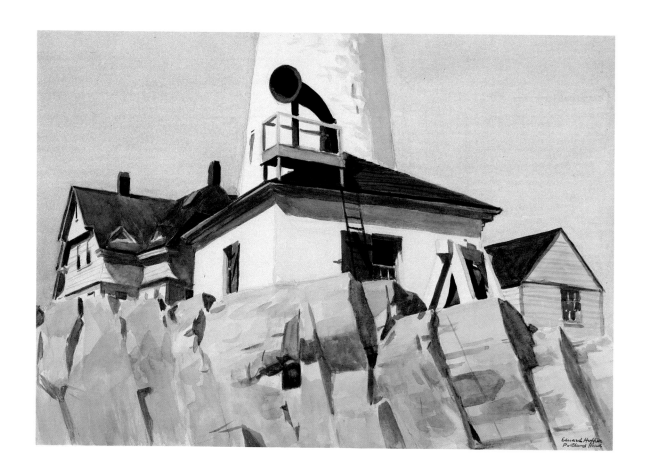

16. EDWARD HOPPER
Rock Pedestal, Portland Head,
1927
Acquired in 1954.

The opportunity she had been waiting for came in due course. Rehn suffered a series of strokes in the period 1952–53 from which he never recovered; Mrs. Beal finally purchased the two paintings in April 1954, just before Rehn's death, conducting the transaction through his assistant, John Clancy.

ARTHUR DOVE

Burchfield, Demuth, and Hopper cover a broad artistic range, but they all fit, just barely, within the confines of conventional taste. While not academic realists, we can generally recognize what they painted; and an accomplished watercolorist like Mrs. Beal would have found much to admire in their technique. The fourth artist whom Mrs. Beal focused on, however, falls into a different cat-

egory. Arthur Dove was in many ways the most radical figure of the Stieglitz group of modernists, the one who pushed painting furthest in the direction of pure abstraction, which most people felt was in the direction of pure nonsense. Moreover, there was nothing elegant or refined about Dove's execution. He liked simple shapes, firm linear outlines, and broad, rather flat brushwork, almost like that of a house painter, but less smooth (the marks of the bristles often show). He avoided any sort of virtuosity of atmosphere or shading; to the untrained eye his work looks childlike.

As a personality, Mrs. Beal was extremely sensible and definite. That she was so attracted to an artist whose work seems difficult and daring even today was, in a way, odd. In the deepest sense, however, Mrs. Beal's enthusiasm for Dove provides a key to what motivated her taste. Abstract or not abstract did not particularly concern her. What she liked were artists who could discover something magical and wondrous in ordinary life. At some level she sensed that Dove was for real, that his art was authentic and sincere.

As with Hopper, all her works by Dove were purchased from a single source, but in this case the dealer was not Frank Rehn but the Downtown Gallery, which had acquired the estate of Alfred Stieglitz. In 1947 she bought the pastel, *Tree Forms* (cat. no. 41), a remarkable work in which meandering patterns of lines evoke the various properties of trees — leaves, knots, bark, growth patterns — without quite resolving into straightforward description. Significantly, Dove worked in pastel and tempera directly on raw plywood, creating an interplay between his image of wood and wood itself.

Two years later Mrs. Beal added four small watercolors to her collection: *Falling Shed Roof* (cat. no. 42), *Barns* (cat. no. 43), *Canandaigua Outlet, Oaks Corner* (cat. no. 44), and *A Barn Here and a Tree There* (cat. no. 45). Though much more modest in effect, these provide a remarkably clear picture of how Dove began with simple descriptive elements, such as buildings and foliage, and gradually wove them into more abstract compositional patterns.

In 1955 she purchased her final work by Dove, the assemblage *Huntington Harbor II*—"a fabulous work," Leon Arkus has commented. Dove's assemblages rank among his greatest achievements, but he produced them for only a short period, from 1924 to 1930, when he and his girlfriend, Helen Torr, lived on a forty-two-

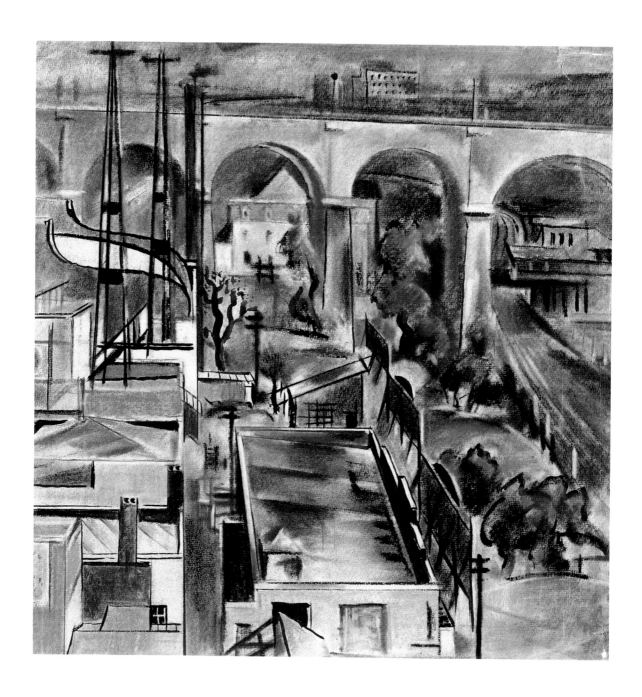

17. Preston Dickinson
Highbridge, c. 1922
Acquired in 1954.

foot yawl moored at Halesite, near Huntington Harbor, Long Island.
The cabin where Dove produced his work was so cramped that he
could not stand upright; paint and canvas were often beyond his
means. Using found materials, Dove began to create assemblages,
soon discovering that the materials themselves inspired him to new
creative combinations. According to Georgia O'Keeffe, "He worked
with collage because it was cheaper than painting and also it amused
him—once he was started on it, one thing after another came to him
very easily with any material he found at hand."[12]

In *Huntington Harbor II* (cat. no. 40), which was executed
on a sheet of metal, Dove used sandpaper and cloth to suggest a sail-
boat, bits of paint-stained wood to evoke pilings, and undulating
streaks of paint to convey sand, sea, and sky. Part of the poignancy
of the work comes from the way in which the materials both repre-
sent and are actual artifacts of the scene that is portrayed. The pur-
chase was certainly one of Mrs. Beal's most remarkable achieve-
ments, not only because it was incredibly bold in 1955 to buy some-
thing so abstract, but also because of the rarity of Dove's assem-
blages. They are scarcer than Vermeers and are seldom seen outside
The Phillips Collection in Washington, D.C., and a few other
eminent museums.

BENTON SPRUANCE AND WILLIAM KIENBUSCH

Mrs. Beal was not infallible, nor have all her purchases
achieved the stature of her works by Burchfield, Demuth, Hopper,
and Dove. In addition to these figures, the Beals also collected the
work of two somewhat younger artists, Benton Spruance and
William Kienbusch, who did distinguished work but who never
attained national fame. In both cases the Beals established personal
friendships with the artists and acquired their works in quantity over
a period of years.

It was natural for Mrs. Beal to come in contact with Benton
Spruance: he showed his prints regularly at Carnegie Institute begin-
ning in 1944; he was represented by the Rehn Gallery; and he lived
in Philadelphia, where Mrs. Beal had undertaken research for her
Eichholtz book. Spruance became as much a personal friend as an
artist she patronized. They corresponded regularly and exchanged

Christmas presents; Spruance even sent her sketches and photographs of his recent work. In 1968, shortly after Spruance's death, one of his dealers, Charles Sessler of Philadelphia, wrote to Mrs. Beal: "It was a matter of deep appreciation when you attended our parties and bought so many of his drawings, which encouraged him."

In fact, the Beals purchased Spruance's work almost by the boatload—at one point they loaned sixty-four prints to a single exhibition. This quantity, however, is not surprising, considering how inexpensive this work was: in 1937 a portfolio of four of Spruance's best lithographs cost $25, with single prints for sale at $7.50 each.

At first the Beals' enthusiasm for Spruance seems misplaced, for at its worst Spruance's work is stiff and stagey, with religious or literary subject matter and self-conscious borrowings from earlier art. Large black lines run through his compositions, suggesting cubist planes, but without much logic, like the leadlines in repaired stained glass. He was an earnest but clumsy draftsman; his blocky, uncertain web of outlines surrounded and encased the outer shell of a form like wrapping paper, without ever quite becoming the form itself, as Demuth's lines do in even his most casual works. This awkward technique, however, becomes effective in his best lithographs of the 1930s, in which the figures are transformed into puppets tied together in an overall rhythm of design.

The Beals also loved the work of William Kienbusch, a Maine painter who had studied with both Henry Varnum Poor and Stuart Davis. As Hilton Kramer once wrote, Kienbusch followed the "painterly tradition of lyric response," in the mold of such figures as John Marin and Marsden Hartley.[13] During the period when they summered in Maine, the Beals made annual visits to Kienbusch's studio and seldom came away empty-handed. Mrs. Beal noted in a letter of April 22, 1980, to Mildred H. Cummings: "We too loved Bill Kienbusch and for years since our Maine sailing days we owned probably more than a dozen paintings, drawings, etc.—many now at Princeton and two I believe at Carnegie here—...."

The Beals left two paintings by Kienbusch to The Carnegie Museum of Art and one to the Bowdoin College Museum of Art in Brunswick, Maine. But they left the bulk of their Kienbusch collection to The Art Museum at Princeton University, Jim Beal and Kienbusch's alma mater. Between 1962 and 1983 they donated

18. CHARLES DEMUTH
White Lilacs, 1923
Acquired in 1954.

49

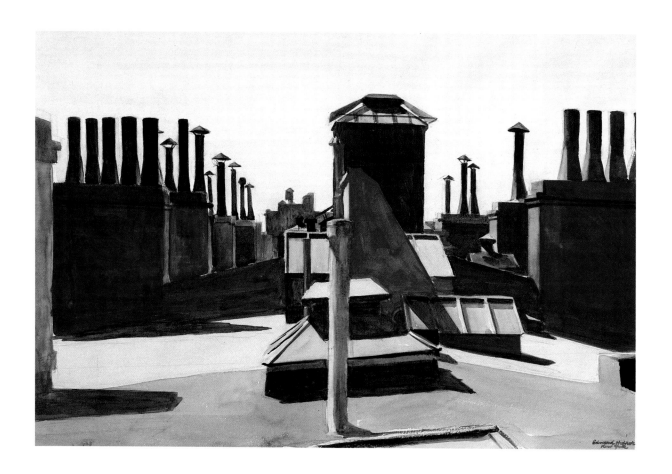

19. EDWARD HOPPER
Roofs, Washington Square, 1926
Acquired in 1954.

twenty works by Kienbusch to Princeton, including paintings, water-colors, and drawings.[14]

REGIONALISM AND MODERNISM

An interesting feature of Mrs. Beal's collecting is that she crossed one of the traditional dividing lines of early twentieth-century art, that between the so-called "Regionalists" and the "Modernists." Both Hopper and Burchfield were featured in the famous story in *Time* magazine that created the concept of Regionalism and that also included the work of Reginald Marsh, Thomas Hart Benton, John Steuart Curry, and Grant Wood.[15] Demuth and Dove, on the other hand, were members of the rival Stieglitz group.

Mrs. Beal did not consistently collect in either area. With regard to Regionalism she had no interest in social realism. She

preferred work that was more poetic in sentiment. Occasionally she would pick up a drawing or oil sketch by a realist artist of the 30s, such as John Carroll, Eugene Speicher, or Henry Varnum Poor. But she certainly was not interested in the Regionalist movement or the rhetoric associated with it.

She came closer to orthodoxy in her collecting of Modernist works, but here also she completely lacked the stamp-collector mentality, which insists on one of everything, regardless of its individual quality. In addition to Demuth and Dove, she acquired work by most of the other members of the Stieglitz group: two oils and a drawing by Marsden Hartley; a drawing and a watercolor by John Marin; and a small still-life painting by Alfred Maurer. But she never bought anything by Georgia O'Keeffe — either this work was already too expensive, or she wasn't interested. This left a conspicuous gap in her representation of the artists whom Stieglitz advocated.

In two instances she branched out into Precisionism: a gouache of an abstracted barn by Charles Sheeler, *Thundershower* (cat. no. 72), and a beautiful pastel titled *Highbridge* (cat. no. 39) by Preston Dickinson. Neither of these, however, is entirely typical of the traits we associate with Precisionism. The Sheeler deals with a rural subject, whereas the Dickinson possesses a delicacy of color and decorative beauty of arrangement that brings to mind Japanese prints and the aestheticism of the turn of the century.

One cannot but be struck that Mrs. Beal often acquired works from supposedly opposite artistic camps that nonetheless possess definite artistic affinities. Her still life by Henry Varnum Poor, for example, has a vibrancy of color that recalls her painting by Alfred Maurer, as well as a Cézannesque quality that is reminiscent of her drawing by Marsden Hartley. Her figure drawing by John Carroll has a directness of line that resonates with her figure drawings by Charles Demuth. Often it is difficult to know what label to put on the works she collected. Her watercolor by Andrew Wyeth, for instance, is surprisingly abstract. Is it closer to Winslow Homer or John Marin? Should we consider it a realistic work, in the illustrative tradition of Wyeth's father, or should we compare it with the contemporary paintings of the Abstract Expressionists?

"I don't think she ever thought of a work being part of an artistic movement," Leon Arkus remarked. "She responded to it as

20. ARTHUR G. DOVE
 Huntington Harbor II, c. 1926
 Acquired in 1955.

21. CHARLES DEMUTH
 Three Apples with Glass, c. 1925
 Acquired in 1956.

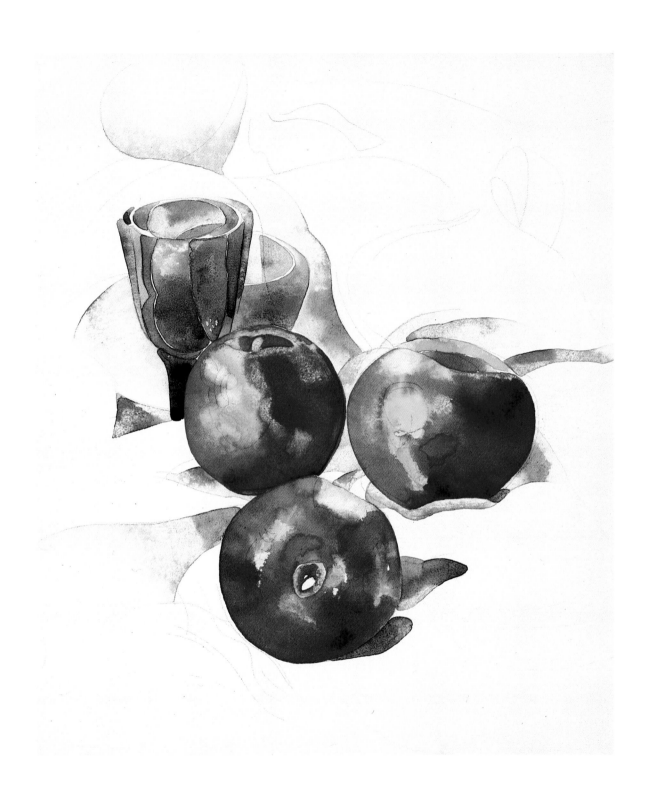

an individual thing. She loved Joan Mitchell and hated Sam Francis. When she liked something or didn't like something, she either liked it immensely or she hated it."

While not interested in Regionalism as an artistic style, Mrs. Beal was definitely interested in art that related to places she loved. Her enthusiasm for Maine led her to acquire Maine seascapes by John Marin and Andrew Wyeth as well as a watercolor of a light-house by Edward Hopper. Having grown up in Pittsburgh, she acquired works by most of the significant artists associated with the city: drawings and paintings by David Gilmour Blythe; a large, important oil by the primitive painter John Kane; a landscape by Johanna K.W. Hailman, a local Impressionist; and pieces by such living local artists as Roger Anliker and Virgil Cantini. (She also liked to acquire work by artists who had made a splash at the Carnegie Internationals—Peter Blume and Charles Burchfield.) Charles Demuth may have appealed to her in part because of his strong association with Lancaster, Pennsylvania. In addition, she liked certain subjects. Sailing was Mr. Beal's favorite leisure pas-time, so she acquired paintings of boats by Winslow Homer, Edward Hopper, Lyonel Feininger, and Arthur Dove.

THE NINETEENTH CENTURY

In addition to twentieth-century works, Mrs. Beal also acquired important nineteenth-century pieces. During her genera-tion, the history of American art was being rewritten by scholars such as Lloyd Goodrich and E. P. Richardson, who disparaged those artists who had followed European models too closely, even when their work was pretty, but admired those who dealt with American subject matter in a blunt, realistic fashion—Winslow Homer and Thomas Eakins, for instance. These writers also liked artists who developed an eccentrically original approach, such as Albert Ryder or Maurice Prendergast.

Generally Mrs. Beal's taste was in accord with this new sen-sibility. She wasn't interested in prettiness — scenes of summer days or charming women in nice dresses. She favored work that was honest and direct. Over the years she managed to acquire works by three of the great figures of nineteenth-century American art—

22. CHARLES DEMUTH
Bartender at the Brevoort, c. 1912
Acquired in 1956.

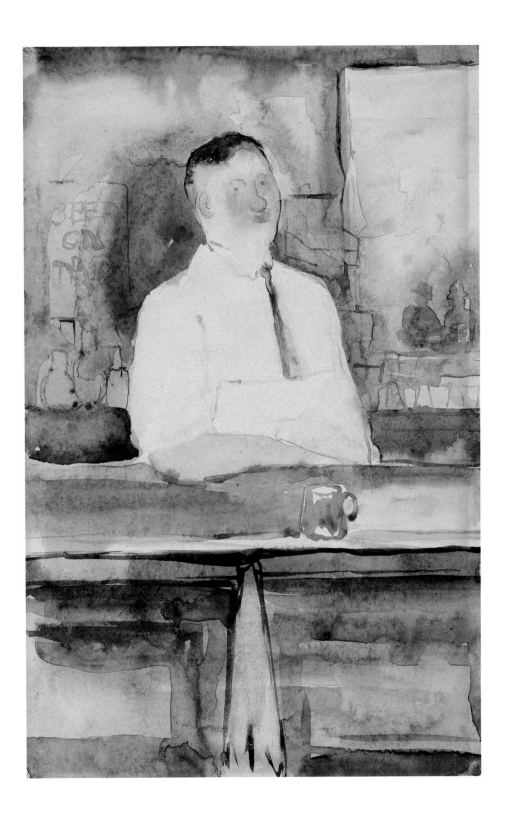

Homer, Eakins, and Prendergast—although for various reasons she often chose rather quirky examples.

In the case of both Homer and Eakins, Mrs. Beal could not afford—or felt she could not afford—any of their major works. Her one Winslow Homer was distinctly slight—a sketch of the yacht *Kulinda* that Homer gave to its owner, Mr. Marsh, who was a personal friend. Frank Rehn found the sketch through a Gloucester, Massachusetts, bank where it had languished in a vault for many years; he sold it to Mrs. Beal shortly afterwards.

Mrs. Beal's Eakins, while also not a work of major significance, has an interesting history, being an oil sketch for the painting *Salutat* (1898; Addison Gallery of American Art, Phillips Academy, Andover, Massachusetts). Eakins gave the sketch to the art critic Sadakichi Hartmann. Hartmann was the first historian of American art to single out Winslow Homer and Thomas Eakins as the two most forceful American realists. He wrote a page or two of praise for both of them in his 1902 history of American art.[16] In gratitude, Eakins gave Hartmann the oil sketch for *Salutat*. It was a subject appropriate to the occasion; Eakins had clearly intended this scene of victory after a boxing match to serve as a metaphor for his own destined artistic triumph, despite the pummeling he had received over the years from the public and unfriendly art critics.

From Hartmann the sketch passed on to two distinguished American painters, the still-life painter Emil Carlsen and his son Dines Carlsen. Mrs. Beal purchased it from the Maynard Walker Gallery. After a trip to New York, Paul Chew, the director of the Westmoreland County Museum of Art in Greensburg, Pennsylvania, mentioned to her that he had seen the painting at the Walker Gallery. Within a few days Mrs. Beal had followed up on his remarks. It is fitting that she gave the painting to Carnegie Institute, as both Eakins and Hartmann are linked to the history of the Museum. Eakins had exhibited *Salutat* in the 1899 Carnegie International, and Hartmann had been hired to assemble an American drawing collection for Carnegie Institute during its early years.

Although superior works by Homer and Eakins were beyond her reach, Mrs. Beal did acquire a top-quality Prendergast—*The Picnic* (cat. no. 71). She bought it from Antoinette Kraushaar, who, as a girl, had known the artist and whose father handled Prendergast's work.

In addition to these blue-chip artists, Mrs. Beal also acquired works by lesser-known figures for whom she felt a personal enthusiasm, such as Jacob Eichholtz and the eccentric Pittsburgh painter David Gilmour Blythe.

Given her devotion to the study of Jacob Eichholtz, it was natural for her to acquire a pair of handsome portraits by him, a husband and wife, which she donated to Carnegie Institute in 1972. She had first seen the paintings at the Baltimore Museum of Art. Although they were unsigned, she attributed them to Eichholtz and proposed that they had been painted around 1815. In 1957 she purchased the portraits and had them cleaned: during the cleaning Eichholtz's signature and the date 1815 were found on the reverse.

Of even greater importance was her interest in the Pittsburgh artist David Gilmour Blythe, a sardonic satirist who created a unique record of the squalor of nineteenth-century urban life. In 1954 Mrs. Beal provided funds for the Museum to purchase a group of works at a small auction in East Liverpool, Ohio, from the estate of the artist's nephew, Heber H. Blythe. This was a gratifying instance of being in the right place at the right time, as it cost only $550 to purchase three paintings and two drawings. The paintings, to be sure, are hardly substantial works, but the two drawings, *Portrait of the Artist* (cat. no. 3) and *A Free-Trade Man* (cat. no. 4), are among Blythe's most arresting and rank high among nineteenth-century American drawings.

Blythe is now included in every noteworthy survey of American art, but in 1954 he was essentially a forgotten figure. What drew Mrs. Beal to him? There can be little doubt that the connecting link was Dorothy Miller — not the Dorothy Miller who curated shows at the Museum of Modern Art, but her more obscure *doppelgänger*, who taught for many years in the English department of the University of Pittsburgh and was close to Mrs. Beal's friend John O'Connor. Along with Harold Barth of East Liverpool, Ohio, Dorothy Miller organized the first exhibition of Blythe's work at Carnegie Institute in 1932, followed by one in East Liverpool in 1934 and another at the Whitney Museum of American Art in 1936. It was during the preparations for these shows that they first discovered the holdings of Heber Blythe — including the two drawings, both previously unrecorded, which were buried in a stack of the artist's doggerel poetry. With her usual decisiveness, when Heber

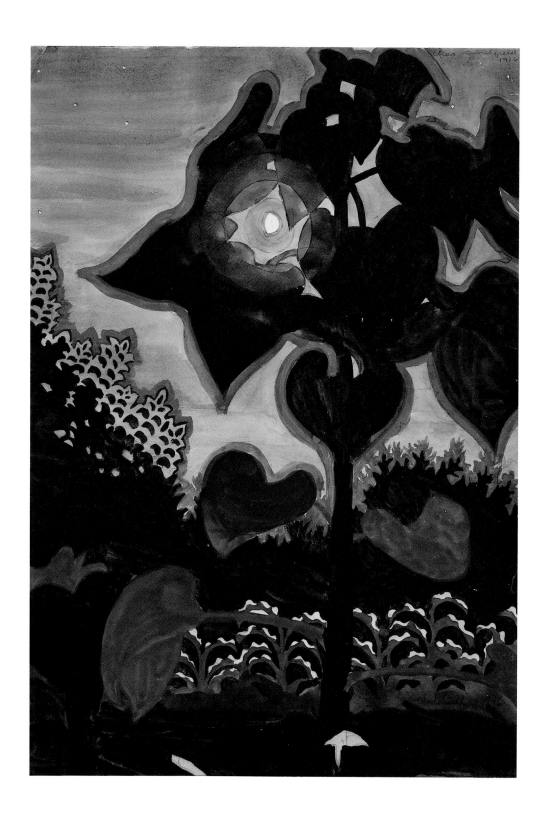

Blythe died, Mrs. Beal swooped in to acquire his things and promptly donated them to the most suitable public collection in Pittsburgh. In 1950, when Dorothy Miller published her biography of Blythe, she reproduced Mrs. Beal's *Portrait of the Artist* as the frontispiece.

PATTERNS

How did Mrs. Beal finance her collecting? The pattern of her payments suggests that she was working within strictly defined limits. Rarely did she spend more than a thousand dollars on a work of art; when she did, it appears to have been a strain on her budget. It often took her a year or more (seven or eight installments) to fund one of these more ambitious purchases. While I can't prove it, I have the impression that for the most part she worked from a household allowance — probably a fairly generous one — and acquired artworks with the money that another woman might have spent on clothing, jewelry, and home redecoration. (Simple dresses and sensible shoes were perfectly satisfactory to Mrs. Beal; I have already mentioned the Beals' plain style of living.) Occasionally, I'm sure, Mr. Beal must have stepped in with additional funds, for example when a purchase was being considered as an immediate gift to the Museum or when a truly extraordinary opportunity came up, such as the two Hopper watercolors from Frank Rehn's collection, for which Mrs. Beal paid slightly more than a thousand dollars apiece on the spot. These were unusual occurrences. For the most part she scrimped and saved, fretting over every penny she spent.

What are the limitations of the Beal collection? In regard to earlier art, I rather wish she had purchased one or two magnificent Winslow Homer watercolors, which would have provided a wonderful starting point for what is otherwise a surprisingly complete survey of American watercolor. I cannot but be touched, however, that she was more interested in discovering and supporting living artists than acquiring the work of well-established dead ones. In the area that most interested her, American art from about 1910 to the early 1940s, the collection shows an uncanny instinct for artistic quality. To be sure, on occasion she acquired works by artists who are not now considered major figures, such as Benton Spruance, John Carroll, and Henry Varnum Poor; but she generally paid little for them,

23. CHARLES E. BURCHFIELD
Moon Through Young Sunflowers,
1916
Acquired in 1956.

and the works themselves are invariably interesting. In certain instances — the work of Demuth, for example — one might fault her for hunting for bargains rather than seeking out a smaller number of greater works. In addition, she did not systematically fill in gaps, as is suggested by her omission of an O'Keeffe. Nonetheless, her overall achievement is remarkable.

With work after 1940, the collection begins to lose its cohesion, although she did make some excellent purchases, such as an oil by William Baziotes, *Black Night* (cat. no. 1) and works on paper by both Mark Tobey and Morris Graves. (Leon Arkus recalled that Mrs. Beal "liked Tobey and Morris Graves. In a very peculiar way, they sum up her taste.") The fact is, Abstract Expressionism represented a somewhat alien sensibility to her — not so much in its abstraction as in its mood of extremism. The artists whom Mrs. Beal loved best, even such abstract ones as Arthur Dove, created their art from an involvement with ordinary, daily experience. She liked artists who could discover the exceptional in the seemingly mundane.

These comments are perhaps more useful as a way of getting a grasp on the parameters of what the Beals accomplished than as serious criticism. In fact, part of what I find most delightful in the Beal collection is its quirkiness, the sense it conveys of an adventurous, actively engaged sensibility, rather than of a rote following of predetermined goals. In many ways it feels like an artist's collection — and Mrs. Beal was indeed an artist, of genuine talent if not of stature.

Her artist's bias is apparent in the emphasis on drawings and watercolors, media that reveal the working process, rather than on large oil paintings or academically polished works. With the exception of a few large watercolors by Burchfield, such as *The Great Elm*, Mrs. Beal seldom purchased big exhibition pieces. Her preference was for smaller, more intimate works, of the kind that artists themselves collect and exchange among each other or that possess some particular association with the creator: for example, the sketches and watercolors that Demuth gave to Robert Locher; the Dickinson pastel that belonged to Arthur Davies; the watercolor that Winslow Homer gave to his friend Mr. Marsh; the sketch that Eakins gave to the art critic Sadakichi Hartmann and that passed on to the painters Emil and Dines Carlsen; and the Hopper watercolors that came from the personal collection of his dealer, Frank Rehn. The Beal collection is not

24. CHARLES DEMUTH
*The Artist on the Beach at
Provincetown*, 1934
Acquired in 1960.

simply a collection of valuable things but one that draws the viewer into the intimate world of artistic creation.

Like many of the best collectors, Mrs. Beal was eventually priced out of the market, not only because she could no longer afford good things, but also because she could not stomach spending hundreds of times what she had paid for these same artists at the beginning of her collecting activities. In addition, as Leon Arkus recalled, "Towards the end she stopped. I don't think she travelled very much. At a certain point she rarely came over to the Museum. I don't know if she had any close friends. She was very much alone."

At times she may have lost faith in what she had accomplished. At one point, for instance, she asked Leon Arkus to provide appraisals of the Demuth watercolors she had collected. She knew they had become more valuable, she felt they weren't really significant, and she was considering selling them. Fortunately, she did not. Upon her death on April 23, 1993, virtually the entire Beal collection came to The Carnegie Museum of Art. It is certainly one of the three or four most important art bequests in the Museum's history.

Looking over this essay, I cannot help asking myself what Mr. and Mrs. Beal would think if they could read it. Their first reaction, I feel pretty sure, would be one of distress. Mr. Beal would become red-faced and would look stiff and uncomfortable about having been placed in the spotlight and about the personal matters that have been revealed. Mrs. Beal would purse her lips and look fretful, not only at the intrusion into their private affairs but also at all the small errors, omissions, and misunderstandings of which I have no doubt been guilty. In her firm hand she would pencil corrections in the margins, then file the manuscript away in some dark place under a heavy stack of other papers.

Perhaps they would both forgive me if they knew the spirit in which this is written. For the Beals do deserve a tribute, do deserve to be remembered, not only for how they lived but for what they believed in. They both showed that the extraordinary can exist within the seemingly ordinary. They demonstrated this with their lives—so outwardly inconspicuous, so inwardly rich—and through the collection that they assembled, in which everyday American scenes take on an amazing spiritual intensity.

For all their modesty and distaste for publicity, the Beals

were thoroughly public spirited. It was in keeping with the style of their lives that they wanted to leave their collection to a public institution, for the benefit of the people of Pittsburgh. It would give them great pleasure to know that others can continue to enjoy the works of art that meant so much to them.

HENRY ADAMS
Director
Cummer Gallery of Art
Jacksonville, Florida

NOTES

For help in writing this essay I am indebted to three staff members at The Carnegie Museum of Art: Louise Lippincott, curator of fine arts; Linda Batis, assistant curator of fine arts; and Gillian Belnap, head of publications, who has edited the piece with sensitivity and a fine eye for detail. Both Marianne Berardi and Kenneth J. Neal made a number of helpful suggestions. For the most part this essay draws on unpublished sources, particularly Mrs. Beal's papers documenting her collection, which came to The Carnegie Museum of Art as part of her bequest. I have also made extensive use of my interviews with Leon Arkus (on September 17, 1993) and Joseph Van Buskirk (on October 19, 1993). Quotations not otherwise credited are taken from these three sources. A number of the works that the Beals donated to the Museum are recorded in two catalogues: *American Drawings and Watercolors in the Museum of Art, Carnegie Institute,* introduction by Henry Adams (Pittsburgh: Carnegie Institute, Museum of Art, 1985) and Diana

Strazdes, et al., *American Paintings and Sculpture to 1945 in The Carnegie Museum of Art* (New York: Hudson Hills Press in association with The Carnegie Museum of Art, 1992).

1. Betsy Fahlman, *Pennsylvania Modern: Charles Demuth of Lancaster* [exhibition catalogue], Philadelphia Museum of Art, 1983. The exhibition was on view at the Museum of Art, Carnegie Institute, from November 23, 1983, to January 22, 1984.

2. See Henry Adams, "The Beal Collection of Watercolors by Charles Demuth," *Carnegie Magazine* 56 (November/December 1983), pp. 21–28. An annotated checklist providing information on the exhibition history and provenance of the Beal watercolors was distributed at the Demuth exhibition. I am grateful to Elizabeth Prelinger, the Museum of Art's assistant curator of fine arts at the time, who was enormously helpful both in organizing the Demuth material and in facilitating communication with Mrs. Beal.

3. Ralph H. Demmler, "A Tale of Two Generations," *Pittsburgh Legal Journal* 135 (May 1987), pp. 32–33.

4. Rebecca J. Beal, with a contribution by E. P. Richardson, *Jacob*

Eichholtz 1776–1842: Portrait Painter of Pennsylvania (Philadelphia: The Historical Society of Pennsylvania, 1969).

5. John I. H. Baur, *The Inlander: Life and Work of Charles Burchfield, 1893–1967* (East Brunswick, N. J. and London: Associated University Presses, Inc., and Cornwall Books, 1982), pp. 147–48.

6. For my account of Burchfield's relationship with Mrs. Beal, I have drawn much of my information from an unpublished essay by Janet Marstine, "Charles Burchfield's Letters to Mrs. James H. Beal" (museum files, The Carnegie Museum of Art, Pittsburgh).

7. The collections of Robert Locher and Richard Weyand were dispersed at two sales at the Parke-Bernet Galleries, Inc., New York: "Watercolors and Paintings by Charles Demuth: Part One of the Collection Belonging to the Estate of the Late Richard W. C. Weyand, Lancaster, Pennsylvania," Public Auction Sale no. 1772, October 16, 1957 (brochure, checklist); and same title, "Part Two," Public Auction Sale no. 1804, February 5, 1958. For a useful listing of exhibitions and sales of Demuth's work see Barbara Haskell, *Charles Demuth* (New York: Whitney Museum of American Art in association with Harry N. Abrams, Inc., Publishers, New York, 1988), pp. 218–36.

8. Lloyd Goodrich, *Edward Hopper* [exhibition catalogue], Whitney Museum of American Art, New York, 1964, p. 22.

9. Charles Burchfield, "Hopper: Career of Silent Poetry," *Art News* 49 (March 1950), p. 17.

10. In a letter of 1972 to Stephanie Farrell, research assistant at the Museum of Art, Carnegie Institute, Mrs. Beal noted that: "This oil was purchased directly from Mr. Rehn in his gallery, not long after he had received it, as I recall. Our mutual enthusiasm about the painting was keen and the painting was saved as a [Christmas] gift to Mr. Beal the same year it was purchased. Until lately it was hung in his office."

11. David Wilkins, "Edward Hopper's Hidden Self-Portrait," *Carnegie Magazine* 55 (March 1981), pp. 4–6.

12. Barbara Haskell, *Arthur Dove* [exhibition catalogue], San Francisco Museum of Art, 1974, p. 49.

13. Hilton Kramer, in Laurie Johnston, "William Kienbusch, Painter, 65; Known for Landscapes of Maine," *The New York Times*, Mar. 24, 1980, Section B, p. 9.

14. My thanks to Barbara T. Ross, associate curator of prints and drawings, The Art Museum, Princeton University, who provided me with records of the Beals' donations to Princeton.

15. [Alexander Elliott], "U. S. Scene," *Time* 24 (December 1934), pp. 24–27.

16. Sadakichi Hartmann, *A History of American Art* (New York: Tudor Publishers, 1932; first edition, 1902), vol. 1, pp. 200–07.

1941	Burchfield	*Winter Rain from the East,* 1940 (The Art Museum, Princeton University)	Frank K. M. Rehn, Inc.
1944	Burchfield	*The Great Elm,* 1939–41 (cat. no. 21)	Frank K. M. Rehn, Inc.
1945	Burchfield	*Snow-Covered Alley,* 1916 (cat. no. 9)	Frank K. M. Rehn, Inc.
1946	Burchfield	*Railroad at Night,* 1920 (cat. no. 15)	Frank K. M. Rehn, Inc.
		Sun Glitter, 1945 (cat. no. 24)	
		Wires Down, 1920 (cat. no. 16)	
1947	Demuth	*Grapes and Turnips,* 1926 (cat. no. 37)	The Downtown Gallery, Inc.
1947	Dove	*Tree Forms,* c. 1928 (cat. no. 41)	The Downtown Gallery, Inc.
1947	Hopper	*Saltillo Rooftops,* 1943 (cat. no. 60)	Frank K. M. Rehn, Inc.
1947	Marin	*Sea Piece No. 21, Small Point, Maine,* 1928 (cat. no. 66)	The Downtown Gallery, Inc.
1948	Burchfield	*Crow and Pool,* 1920 (cat. no. 14)	Kraushaar Galleries, Inc.
1948	Demuth	*Architecture,* 1918 (cat. no. 34)	Kraushaar Galleries, Inc.
1948	Kuniyoshi	*Mother and Child,* 1946–47 (cat. no. 63)	The Downtown Gallery, Inc.
1949	Dove	*Falling Shed Roof,* 1934 (cat. no. 42)	The Downtown Gallery, Inc.
		Barns, 1935 (cat. no. 43)	
		Canandaigua Outlet, Oaks Corner, 1937 (cat. no. 44)	

1949	Dove	*A Barn Here and a Tree There*, 1940 (cat. no. 45)	The Downtown Gallery, Inc.
1949	Prendergast	*The Picnic*, 1901 (cat. no. 71)	Kraushaar Galleries, Inc.
1949	Sheeler	*Thundershower*, 1948 (cat. no. 72)	The Downtown Gallery, Inc.
1950	Demuth	*Two Figures: Turkish Bath*, 1915 (cat. no. 29)	Robert Locher
1950	Demuth	*In Vaudeville: Two Acrobats on Bicycle*, 1915–16 (cat. no. 30)	Frank K. M. Rehn, Inc.
		Acrobats: Two Figures Bowing, 1916 (cat. no. 31)	Edwin P. Hewitt Gallery
		Tree, c. 1916 or 1920 (cat. no. 33)	Gift of Robert Locher
1950	Feininger	*Luminosity*, 1948 (cat. no. 49)	Buchholz/Curt Valentin Gallery
1951	Burchfield	*Song of the Wood Thrush*, 1950 (cat. no. 25)	Frank K. M. Rehn, Inc.
1951	Demuth	*White Horse*, 1912 (cat. no. 27)	Richard Weyand
1951	Hartley	*Garmisch-Partenkirchen*, c. 1933–34 (cat. no. 53)	Bertha Schaefer Gallery
1951 or 1952	Homer	*The Sloop Kulinda*, c. 1880 (cat. no. 55)	Frank K. M. Rehn, Inc.
1952	Hopper	*Sailing*, c. 1911 (cat. no. 56)	Frank K. M. Rehn, Inc.
1953	Burchfield	*Insects and Moon*, 1917 (cat. no. 10)	The artist
		Spider and Butterfly, 1917 (cat. no. 11)	
		Winter Twilight, 1918 (cat. no. 12)	
		Swamp Landscape, 1919 (cat. no. 13)	
		House with an Astonished Face, 1922 (cat. no. 17)	
		Young Elms, 1927 (cat. no. 18)	
		Cruciform House in Pennsylvania, 1935 (cat. no. 19)	
		Huddled Houses, 1938 (cat. no. 20)	
		Maple Tree, 1944 (cat. no. 22)	

1953	Burchfield	*Oak Branch*, 1944 (cat. no. 23)	The artist
1953	Hopper	*Tree, Maine*, 1925–30 (cat. no. 57)	Frank K. M. Rehn, Inc.
1953	Wyeth	*September Sea*, c. 1953 (cat. no. 91)	William Macbeth Gallery, Inc.
1954	Blythe	*Portrait of the Artist*, c. 1848 (cat. no. 3)	Estate of Heber H. Blythe
		A Free-Trade Man, c. 1854–58 (cat. no. 4)	
		Rebecca Describes the Battle to Ivanhoe, 1859–63 (cat. no. 6)	Haugh and Keenan Galleries
1954	Demuth	*White Lilacs*, 1923 (cat. no. 35)	Durlacher Brothers
1954	Dickinson	*Highbridge*, c. 1922 (cat. no. 39)	Frank K. M. Rehn, Inc.
1954	Hopper	*Roofs, Washington Square*, 1926 (cat. no. 58)	Frank K. M. Rehn, Inc.
		Rock Pedestal, Portland Head, 1927 (cat. no. 59)	
1954	Kane	*Bloomfield Bridge*, c. 1930 (cat. no. 61)	Maynard Walker Gallery
1954	Wilde	*Self-Portrait with Milkweed*, 1954 (cat. no. 90)	Edwin P. Hewitt Gallery
1955	Baziotes	*Black Night*, 1954 (cat. no. 1)	Samuel Kootz Gallery
1955	Blythe	*Man Putting on Boots*, c. 1856–60 (cat. no. 5)	Donald Cadwalader Scully
1955	Dove	*Huntington Harbor II*, c. 1926 (cat. no. 40)	The Downtown Gallery, Inc.
1956	Burchfield	*Impression of Lightning, July 15, 1916*, 1916 (cat. no. 7)	Frank K. M. Rehn, Inc.
1956	Burchfield	*Moon Through Young Sunflowers*, 1916 (cat. no. 8)	Frank K. M. Rehn, Inc.
1956	Demuth	*Bartender at the Brevoort*, c. 1912 (cat. no. 28)	Gift of Edgar J. Kaufmann, Jr.
		Bathers, c. 1916 (cat. no. 32)	Robert Locher
		Three Apples with Glass, c. 1925 (cat. no. 36)	
1956	Morris	*Autumn #3*, 1954 (cat. no. 68)	Kraushaar Galleries, Inc.
1957	Eichholtz	*Portrait of a Man*, 1815 (cat. no. 47)	Joseph Katz
		Portrait of a Woman, 1815 (cat. no. 48)	

1958	Blume	*Hanging Shirt,* 1956 (cat. no. 2)	Durlacher Brothers
1958	Eakins	*Study for "Salutat,"* 1898 (cat. no. 46)	Maynard Walker Gallery
1960	Demuth	*The Artist on the Beach at Provincetown,* 1934 (cat. no. 38)	Maynard Walker Gallery
1961	Greene	*Collage,* 1936 (cat. no. 51)	The American Federation of Arts
1962	Hartley	*Carros—Looking Toward the Italian Alps,* 1927 (cat. no. 52)	Babcock Galleries
1962	Kuhn	*Two Clowns with Dog,* 1940 (cat. no. 62)	Maynard Walker Gallery
1962	Marin	*Bennington, Vermont,* c. 1924 (cat. no. 65)	Women's Committee Auction, Carnegie Institute

DATES OF PURCHASE UNKNOWN

1952?	Poor	*Figs in a Bowl,* c. 1952 (cat. no. 70)	Frank K. M. Rehn, Inc.
by 1957	Carroll	*Nude,* n.d. (cat. no. 26)	Frank K. M. Rehn, Inc.
by 1957	Graves	*Bouquet,* c. 1950 (cat. no. 50)	Frank K. M. Rehn, Inc.
by 1957	Maurer	*Still Life with Fish,* c. 1927 (cat. no. 67)	Weyhe Gallery
by 1957	Poor	*Across the Marshes,* 1951 (cat. no. 69)	Frank K. M. Rehn, Inc.
by 1957	Speicher	*Nude,* n.d. (cat. no. 73)	Frank K. M. Rehn, Inc.
by 1958	Libby	*Lanterns,* 1945 (cat. no. 64)	Unidentified
by 1963	Tobey	*Bacchanale,* 1957 (cat. no. 89)	Willard Gallery
	Hartley	*Robin,* c. 1940–41 (cat. no. 54)	Paul Rosenberg & Co.

Black Night

1. WILLIAM BAZIOTES
 1912–1963

Black Night, 1954

Oil on canvas
36 x 48 in. (91.4 x 122 cm)
Signature, date: Baziotes 1954
(lower right); William Baziotes
1954 (on reverse)

EXHIBITIONS: Department of Fine
Arts, Carnegie Institute, Pittsburgh,
1955, *The 1955 Pittsburgh
International Exhibition of
Contemporary Painting,* no. 15;
Colorado Springs Fine Arts Center,
1956, *New Accessions, U.S.A.,*
no. 10; Baltimore Museum of Art,
1956, *4000 Years of Modern Art*
(trav. exh.), no. 122; Solomon R.
Guggenheim Museum, New York,
1961, *American Vanguard* (trav.

exh.), no catalogue; American
Embassy, London, 1962; American
Embassy, Darmstadt, Germany,
1962; The American Federation of
Arts, New York, 1964–65, *Great
Paintings from the Fifties* (trav.
exh.), no. 5; Allentown Art
Museum, Pa., 1973, *Modern Art
from Pittsburgh,* no catalogue.

PROVENANCE: Samuel Kootz
Gallery, New York, through the
1955 *Pittsburgh International.*

Patrons Art Fund: gift of Mr. and
Mrs. James H. Beal, 55.32

2. PETER BLUME
 1906–1992

Hanging Shirt, 1956

Pen and ink with black wash on
paper
11 x 8¹/₂ in. (27.9 x 21.6 cm)
Signature, date: P. Blume 1956
(lower right)

REMARKS: This drawing is a study
for Blume's painting *Passage to
Aetna* (1956, Fogg Art Museum,
Harvard University, Cambridge,
Mass.).

Hanging Shirt

PROVENANCE: Durlacher Brothers
Gallery, New York; Mr. and Mrs.
James H. Beal, Pittsburgh, 1958.

Bequest of Mr. and Mrs. James H.
Beal, 93.189.1

3. DAVID GILMOUR BLYTHE
 1815–1865

Portrait of the Artist, c. 1848

Graphite on paper
8¹/₄ x 5¹/₂ in. (21 x 14 cm)
Signatures, inscription: D.G.
Blythe from nothing [written over]
from the original (lower center);

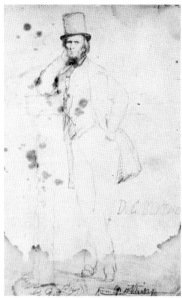

Portrait of the Artist

D.G. Blithe [*sic*] (center right)

REFERENCES: *Columbus* (Ohio) *Dispatch,* Mar. 10, 1898, p. 10; Tom T. Jones, "The Reviewing Stand," *East Liverpool* (Ohio) *Review,* Dec. 1, 1932; John O'Connor, Jr., "Paintings by David G. Blythe," *Carnegie Magazine* 6 (Jan. 1933), p. 230; Evelyn Abraham, "David G. Blythe, American Painter and Wood-carver," *Antiques* 27 (May 1935), p. 181; John O'Connor, Jr., "A Pittsburgh Scene," *Carnegie Magazine* 16 (Jan. 1943), p. 227; Dorothy Miller, *The Life and Work of David G. Blythe* (Pittsburgh, 1950), p. 95; Bruce W. Chambers, "David Gilmour Blythe (1815– 1865): An Artist at Urbanization's Edge," Ph.D. diss., University of Pennsylvania, 1974, pp. 257, 398–99; Elizabeth A. Prelinger, in

American Drawings and Water-colors in the Museum of Art, Carnegie Institute, intro. by Henry Adams (Pittsburgh, 1985), pp. 39–43, 251–52.

EXHIBITIONS: Department of Fine Arts, Carnegie Institute, Pittsburgh, 1933, *An Exhibition of Painting: David G. Blythe,* no. 2; East Liverpool, Ohio, 1934, *Centennial Historical Society Exhibit,* no. 20; Whitney Museum of American Art, New York, 1936, *Paintings by David G. Blythe, 1815–1865— Drawings by Joseph Boggs Beale, 1841–1926,* no. 37; Butler Art Institute, Youngstown, Ohio, 1947, *David G. Blythe,* no. 2; Columbus Museum of Art, Ohio, 1968, *Works by David Gilmour Blythe, 1815– 1865,* no. 1; National Collection of Fine Arts, Washington, D.C., 1980–81, *The World of David Gilmour Blythe, 1815–1865* (trav. exh.), no. 262; Museum of Art, Carnegie Institute, Pittsburgh, 1983, *Masterpieces of American Drawing and Watercolor,* no. 10; Museum of Art, Carnegie Institute, Pittsburgh, 1985, *American Watercolors and Drawings from the Collection of the Museum of Art, Carnegie Institute* (trav. exh.), no catalogue.

REMARKS: This drawing is Blythe's only surviving self-por-trait; the head and upper part of the drawing were probably executed around 1848. At a later date, per-haps around 1854, Blythe added the legs and the post on which the figure leans. It was probably at this time that Blythe added his

signature and an inscription at the bottom of the drawing.

PROVENANCE: The artist's broth-er, Thomas Blythe, East Liverpool, Ohio; his son, Heber H. Blythe, East Liverpool, Ohio; estate of Heber H. Blythe.

Museum purchase: gift of Mr. and Mrs. James H. Beal, 54.31.5

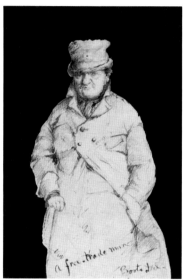

A Free-Trade Man

4. DAVID GILMOUR BLYTHE
1815–1865

A Free-Trade Man, c. 1854–58

Graphite and pen and ink on paper
11 1/4 x 7 3/4 in. (28.6 x 19.7 cm)
Inscription: a free-trade man— Boots Del. (lower left)

REFERENCES: Tom T. Jones, "The Reviewing Stand," *East Liverpool* (Ohio) *Review,* Dec. 1, 1932; Dorothy Miller, *The Life and Work of David G. Blythe* (Pittsburgh, 1950), pp. 76, 125; Bruce W. Chambers, "David Gilmour Blythe

(1815–1865): An Artist at Urbanization's Edge," Ph.D. diss., University of Pennsylvania, 1974, pp. 87, 257, 398, 410; Theodore E. Stebbins, Jr., *American Master Drawings and Watercolors* (New York, 1976), p. 181; Elizabeth A. Prelinger, in *American Drawings and Watercolors in the Museum of Art, Carnegie Institute,* intro. by Henry Adams (Pittsburgh, 1985), pp. 39–43, 252.

EXHIBITIONS: East Liverpool, Ohio, 1934, *Centennial Historical Society Exhibit,* no. 3; Columbus Museum of Art, Ohio, 1968, *Works by David Gilmour Blythe, 1815–1865,* no. 2; Minneapolis Institute of Arts, 1976, *American Master Drawings and Watercolors* (trav. exh.), no. 180; National Collection of Fine Arts, Washington, D.C., 1980–81, *The World of David Gilmour Blythe, 1815–1865* (trav. exh.), no. 260; Museum of Art, Carnegie Institute, Pittsburgh, 1983, *Masterpieces of American Drawing and Watercolor,* no. 9; Museum of Art, Carnegie Institute, Pittsburgh, 1985, *American Watercolors and Drawings from the Collection of the Museum of Art, Carnegie Institute* (trav. exh.), no catalogue.

REMARKS: *A Free-Trade Man* is a satirical portrait of Billy Bleakley, East Liverpool, Ohio. The inscription "a free-trade man" alludes to Bleakley's allegiance to the Democratic party, of which Blythe, an ardent Republican, strongly disapproved.

PROVENANCE: Dr. Benjamin Ogden, East Liverpool, Ohio; Dr. Charles B. Ogden, East Liverpool, Ohio; Millard E. Blythe; the artist's nephew, Heber H. Blythe, East Liverpool, Ohio; estate of Heber H. Blythe.

Museum purchase: gift of Mr. and Mrs. James H. Beal, 54.31.4

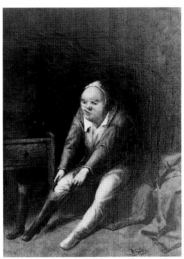

Man Putting on Boots

5. DAVID GILMOUR BLYTHE
1815–1865

Man Putting on Boots, c. 1856–60

Oil on canvas
14 1/2 x 11 in. (36.8 x 27.9 cm)
Signature: Blythe (lower right)

REFERENCES: Dorothy Miller, *The Life and Work of David G. Blythe* (Pittsburgh, 1950), p. 67; John T. Flexner, "The Dark World of David Gilmour Blythe," *American Heritage* 13 (Oct. 1962), p. 26; F. McLaughlin, "Margaret Townsend Scully's Trunk," *Western Pennsylvania Historical Magazine* 53 (Apr. 1970), pp. 162–63; Museum of Art, Carnegie Institute, *Catalogue of the Painting Collection* (Pittsburgh, 1973), p. 17; Bruce W. Chambers, "David Gilmour Blythe (1815–1865): An Artist at Urbanization's Edge," Ph.D. diss., University of Pennsylvania, 1974, pp. 131–32, 421; Rina C. Youngner, in *American Paintings and Sculpture to 1945 in The Carnegie Museum of Art,* by Diana Strazdes, et al. (New York, 1992), pp. 84–85.

EXHIBITIONS: Department of Fine Arts, Carnegie Institute, Pittsburgh, 1933, *An Exhibition of Painting: David G. Blythe,* no. 26; Whitney Museum of American Art, New York, 1936, *Paintings by David G. Blythe, 1815–1865—Drawings by Joseph Boggs Beale, 1841–1926,* no. 25; Columbus Museum of Art, Ohio, 1968, *Works by David Gilmour Blythe, 1815–1865,* no. 10; Westmoreland County Museum of Art, Greensburg, Pa., 1976, *Nineteenth and Early Twentieth Century Regional Painters,* unnumbered; National Collection of Fine Arts, Washington, D.C., 1980–81, *The World of David Gilmour Blythe, 1815–1865* (trav. exh.), no. 135.

PROVENANCE: Henry Rees Scully, Pittsburgh, by 1932; Margaret Jackson Townsend Scully, Pittsburgh; Donald Cadwalader Scully, Pittsburgh, by 1955.

Museum purchase: gift of Mr. and Mrs. James H. Beal, 55.37.1

Rebecca Describes the Battle to Ivanhoe

6. DAVID GILMOUR BLYTHE
1815–1865

Rebecca Describes the Battle to Ivanhoe, 1859–63
(Prison Scene)

Oil on canvas
27 x 22 ¹/₂ in. (68.6 x 57.1 cm)
Signature: Blythe (lower center)

REFERENCES: Museum of Art, Carnegie Institute, *Catalogue of the Painting Collection* (Pittsburgh, 1973), p. 20; Bruce W. Chambers, "David Gilmour Blythe (1815–1865): An Artist at Urbanization's Edge," Ph.D. diss., University of Pennsylvania, 1974, p. 426; Rina C. Youngner, in *American Paintings and Sculpture to 1945 in The Carnegie Museum of Art,* by Diana Strazdes, et al. (New York, 1992), p. 90.

EXHIBITIONS: Columbus Museum of Art, Ohio, 1968, *Works by David Gilmour Blythe, 1815–1865,* no. 9, as *Prison Scene*; National Collection of Fine Arts, Washington, D.C., 1980–81, *The World of David Gilmour Blythe, 1815–1865* (trav. exh.), no. 196.

REMARKS: This painting was directly based on the incident from Sir Walter Scott's novel *Ivanhoe* (1820) in which a wounded knight, Ivanhoe, and a beautiful young Jewish girl, Rebecca, are imprisoned.

PROVENANCE: Eleanor G. McCallam, Pittsburgh; Haugh and Keenan Galleries, Pittsburgh; Mrs. James H. Beal, Pittsburgh, by 1954.

Gift of Mrs. James H. Beal, 54.4

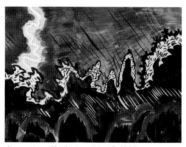

Impression of Lightning, July 15, 1916

7. CHARLES E. BURCHFIELD
1893–1967

Impression of Lightning, July 15, 1916, 1916

Watercolor on paper
8¹/₂ x 11¹/₂ in. (21.6 x 29.2 cm)
Signature: Chas. E. Burchfield (lower right)

REFERENCES: Charles Burchfield, letter to Mrs. James H. Beal, Jan. 17, 1956, Archives of American Art, Washington, D.C.; Munson-Williams-Proctor Institute, *Charles Burchfield, Catalogue of Paintings in Public and Private Collections* (Utica, N.Y., 1970), p. 50.

EXHIBITIONS: Whitney Museum of American Art, New York, 1956, *Charles Burchfield* (trav. exh.), no. 3; Department of Fine Arts, Carnegie Institute, Pittsburgh, 1957, *Drawings and Watercolors from the Collection of Mr. and Mrs. James H. Beal,* no catalogue.

REMARKS: Charles Burchfield to Mrs. Beal on Jan. 17, 1956:

I was so pleased you got the 'Lightening' [sic] and 'Moon Through Young Sunflowers'—I must confess I felt too that many of these early things were 'buried' and wondered why no one ever picked them up. But all's well that ends well; they have a good home with you.

PROVENANCE: Frank K. M. Rehn, Inc., New York; Mr. and Mrs. James H. Beal, Pittsburgh, 1956.

Bequest of Mr. and Mrs. James H. Beal, 93.189.2

8. CHARLES E. BURCHFIELD
1893–1967

Moon Through Young Sunflowers, 1916

Gouache, graphite, and watercolor on paper
19 ⁷/₈ x 14 in. (50.5 x 35.6 cm)
Signature, date: Chas Burchfield 1916 (upper and lower right)
Inscription: Moonlight on Corn (on reverse)

Color illustration 23.

REFERENCES: Charles Burchfield, letter to Mrs. James H. Beal, Jan.

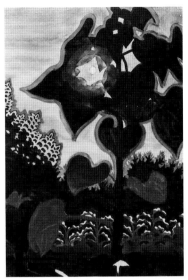

Moon Through Young Sunflowers

17, 1956, Archives of American Art, Washington, D.C.; Munson-Williams-Proctor Institute, *Charles Burchfield, Catalogue of Paintings in Public and Private Collections* (Utica, N.Y., 1970), p. 49; Museum of Art, Carnegie Institute, *Catalogue of the Painting Collection* (Pittsburgh, 1973), p. 31; John I. H. Baur, *The Inlander: Life and Work of Charles Burchfield, 1893–1967* (East Brunswick, N.J., and London, 1982), p. 40; Henry Adams, in *American Drawings and Watercolors in the Museum of Art, Carnegie Institute,* intro. by Henry Adams (Pittsburgh, 1985), pp. 148–49, 253–54; Christopher Finch, *Twentieth-Century Watercolors* (New York, 1988), pp. 212, 214.

EXHIBITIONS: Whitney Museum of American Art, New York, 1956, *Charles Burchfield* (trav. exh.), no. 4; Department of Fine Arts, Carnegie Institute, Pittsburgh, 1957, *Drawings and Watercolors*

from the Collection of Mr. and Mrs. James H. Beal, no catalogue; Museum of Art, Carnegie Institute, Pittsburgh, 1983, *Masterpieces of American Drawing and Water-color,* no. 11; Metropolitan Museum of Art, New York, 1984, *Charles Burchfield Retrospective,* no catalogue; Museum of Art, Carnegie Institute, Pittsburgh, 1985, *American Watercolors and Drawings from the Collection of the Museum of Art, Carnegie Institute* (trav. exh.), no catalogue; Columbus Museum of Art, Ohio, 1987–88, *Early Works of Charles E. Burchfield,* no. 20.

PROVENANCE: Frank K. M. Rehn, Inc., New York; Mr. and Mrs. James H. Beal, Pittsburgh, 1956.

Gift of Mr. and Mrs. James H. Beal, 67.3.5

9. CHARLES E. BURCHFIELD 1893–1967

Snow-Covered Alley, 1916

Graphite, watercolor, and gouache on paper mounted on cardboard
12 1/4 x 9 1/4 in. (31.1 x 23.5 cm)
Signature, date: C. E. Burchfield 1916 (lower right)

Color illustration 2.

REFERENCE: Munson-Williams-Proctor Institute, *Charles Burch-field, Catalogue of Paintings in Public and Private Collections* (Utica, N.Y., 1970), p. 38.

EXHIBITION: Department of Fine Arts, Carnegie Institute, Pittsburgh, 1957, *Drawings and Watercolors*

Snow-Covered Alley

from the Collection of Mr. and Mrs. James H. Beal, no catalogue.

PROVENANCE: Frank K. M. Rehn, Inc., New York; Mr. and Mrs. James H. Beal, Pittsburgh, 1945.

Bequest of Mr. and Mrs. James H. Beal, 93.189.3

Insects and Moon

10. CHARLES E. BURCHFIELD 1893–1967

Insects and Moon, 1917

Graphite and pen and ink on paper mounted on cardboard
5 3/8 x 8 5/16 in. (13.7 x 21.1 cm)
Signature, date: CEB 1917 (lower left)

EXHIBITIONS: Print Club of Cleveland and Cleveland Museum of Art, 1953, *The Drawings of Charles E. Burchfield,* no. 27; Department of Fine Arts, Carnegie Institute, Pittsburgh, 1957, *Drawings and Watercolors from the Collection of Mr. and Mrs. James H. Beal,* no catalogue.

PROVENANCE: The artist; Mr. and Mrs. James H. Beal, Pittsburgh, Cleveland Museum of Art exhibition, 1953.

Bequest of Mr. and Mrs. James H. Beal, 93.189.5

Spider and Butterfly

11. CHARLES E. BURCHFIELD
1893–1967

Spider and Butterfly, 1917

Graphite on paper mounted on cardboard
10 $^7/_8$ x 8 $^7/_{16}$ in. (27.5 x 21.4 cm)
Signature, date: CEB 1917 (lower right)

EXHIBITIONS: Print Club of Cleveland and Cleveland Museum

of Art, 1953, *The Drawings of Charles E. Burchfield,* no. 23; Department of Fine Arts, Carnegie Institute, Pittsburgh, 1957, *Drawings and Watercolors from the Collection of Mr. and Mrs. James H. Beal,* no catalogue.

PROVENANCE: The artist; Mr. and Mrs. James H. Beal, Pittsburgh, Cleveland Museum of Art exhibition, 1953.

Bequest of Mr. and Mrs. James H. Beal, 93.189.4

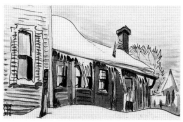

Winter Twilight

12. CHARLES E. BURCHFIELD
1893–1967

Winter Twilight, 1918

Pen and ink and wash on cardboard
5 $^7/_{16}$ x 8 $^7/_{16}$ in. (13.7 x 21.4 cm)
Signature, date: CEB 1918 (lower left)
Inscription: greenish white/new grey? (bottom center)

EXHIBITIONS: Print Club of Cleveland and Cleveland Museum of Art, 1953, *The Drawings of Charles E. Burchfield,* no. 35; Department of Fine Arts, Carnegie Institute, Pittsburgh, 1957, *Drawings and Watercolors from the Collection of Mr. and Mrs. James H. Beal,* no catalogue.

PROVENANCE: The artist; Mr. and Mrs. James H. Beal, Pittsburgh, Cleveland Museum of Art exhibition, 1953.

Bequest of Mr. and Mrs. James H. Beal, 93.189.6

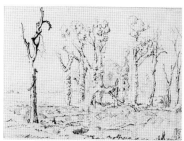

Swamp Landscape

13. CHARLES E. BURCHFIELD
1893–1967

Swamp Landscape, 1919

Pencil on cardboard
10 $^1/_4$ x 14 $^1/_8$ in. (26 x 35.9 cm)
Signature, date: CEB 1919 (lower right)
Inscription: 1919/18 — Swamp Landscape (on reverse)

REFERENCE: *American Drawings and Watercolors in the Museum of Art, Carnegie Institute,* intro. by Henry Adams (Pittsburgh, 1985), p. 254.

EXHIBITIONS: Print Club of Cleveland and Cleveland Museum of Art, 1953, *The Drawings of Charles E. Burchfield,* no. 60; Department of Fine Arts, Carnegie Institute, Pittsburgh, 1957, *Drawings and Watercolors from the Collection of Mr. and Mrs. James H. Beal,* no catalogue.

PROVENANCE: The artist; Mr. and Mrs. James H. Beal, Pittsburgh,

Cleveland Museum of Art exhibition, 1953.

Gift of Mr. and Mrs. James H. Beal, 67.3.7

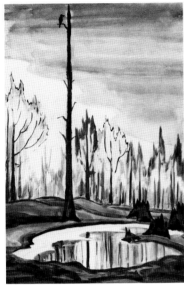
Crow and Pool

14. CHARLES E. BURCHFIELD 1893–1967

Crow and Pool, 1920

Graphite and watercolor on paper mounted on cardboard
26 ¹/₄ x 17 ³/₁₆ in. (66.7 x 43.7 cm)
Signature, date: Chas. E. Burchfield 1918 (lower left)
Inscription: blue white (lower center)/ [illeg.] sky [illeg.] (center)

REFERENCES: Charles Burchfield, letter to Mrs. James H. Beal, Feb. 3, 1948, Archives of American Art, Washington, D.C.; Munson-Williams-Proctor Institute, *Charles Burchfield, Catalogue of Paintings in Public and Private Collections* (Utica, N.Y., 1970), p. 98.

EXHIBITIONS: Department of Fine Arts, Carnegie Institute, Pittsburgh, 1938, *An Exhibition of Watercolors and Oils by Charles Burchfield,* no. 36; Department of Fine Arts, Carnegie Institute, Pittsburgh, 1957, *Drawings and Watercolors from the Collection of Mr. and Mrs. James H. Beal,* no catalogue.

REMARKS: Charles Burchfield to Mrs. Beal on Feb. 3, 1948:

Your picture was painted near the stream known as the 'Little Beaver' which encircled Salem, Ohio. On this particular spot, where the picture was painted (about three miles northwest of Salem) the stream is known locally as the 'Meander' for its usual obvious reason. It was mostly painted on the spot outdoors, with perhaps a little touching up later....

PROVENANCE: Dr. Henry Lyle; Alan Temple, Scarsdale, N.Y.; Kraushaar Galleries, New York; Mr. and Mrs. James H. Beal, Pittsburgh, 1948.

Bequest of Mr. and Mrs. James H. Beal, 93.189.7

15. CHARLES E. BURCHFIELD 1893–1967

Railroad at Night, 1920

Charcoal with watercolor on paper
14 x 18³/₁₆ in. (35.5 x 46.2 cm)
Signature: C. Burchfield (lower right)

REFERENCES: Charles Burchfield, letter to Mrs. James H. Beal, Feb.

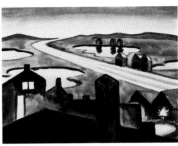
Railroad at Night

3, 1954, Archives of American Art, Washington, D.C.; Munson-Williams-Proctor Institute, *Charles Burchfield, Catalogue of Paintings in Public and Private Collections* (Utica, N.Y., 1970), p. 94.

EXHIBITIONS: Montross Gallery, New York, 1928, *Exhibition of Recent Paintings by Charles E. Burchfield*; Department of Fine Arts, Carnegie Institute, Pittsburgh, 1957, *Drawings and Watercolors from the Collection of Mr. and Mrs. James H. Beal,* no catalogue; Westmoreland County Museum of Art, Greensburg, Pa., 1962, *Founders' Day Exhibition, Works of Art from Local Collections,* no. 10; Albright Knox Art Gallery, Buffalo, N.Y., 1963, *Charles Burchfield, Early Watercolors,* no. 73.

REMARKS: Charles Burchfield to Mrs. Beal on Feb. 3, 1954:

The date of the 'Railroad at Night' is 1920—Not a transcription of any definite scene, but a 'spirit' translation of the railroad section of Salem, Ohio. The P.P.W.V.C. makes a big curve just at the edge of Salem, from West to North and then West again beyond Salem. It

was the effect of the train whistle on a winter night I was trying to express….

PROVENANCE: Montross Gallery, New York; Frank K. M. Rehn, Inc., New York; Mr. and Mrs. James H. Beal, Pittsburgh, 1946.

Bequest of Mr. and Mrs. James H. Beal, 93.189.8

Wires Down

16. CHARLES E. BURCHFIELD
1893–1967

Wires Down, 1920
(Ice Storm)

Graphite, wash, and gouache on paper mounted on cardboard
18 3/4 x 30 7/8 in. (47.6 x 78.4 cm)
Signature, date: Chas. Burchfield—1920 (lower right)

REFERENCES: Charles Burchfield, letters to Mrs. James H. Beal, Dec. 18, 1945, and June 21, 1946, Archives of American Art, Washington, D.C.; Charles Burchfield, letter to John O'Connor, July 1, 1946, museum files, The Carnegie Museum of Art, Pittsburgh; Munson-Williams-Proctor Institute, *Charles Burchfield, Catalogue of Paintings in Public and Private Collections* (Utica, N.Y., 1970), p. 92; Museum of Art, Carnegie Institute, Pittsburgh,

Catalogue of the Painting Collection (Pittsburgh, 1973), p. 31; *American Drawings and Watercolors in the Museum of Art, Carnegie Institute,* intro. by Henry Adams (Pittsburgh, 1985), pp. 148, 150, 254.

EXHIBITIONS: Galerie de la Chambre Syndicale des Beaux-Arts, Paris, 1924, *Exhibition of American Art,* as *Ice Storm;* Whitney Museum of American Art, New York, 1956, *Charles Burchfield* (trav. exh.), no. 35; Department of Fine Arts, Carnegie Institute, Pittsburgh, 1957, *Drawings and Watercolors from the Collection of Mr. and Mrs. James H. Beal,* no catalogue; Munson-Williams-Proctor Institute, Utica, N.Y., 1970, *The Nature of Charles Burchfield—A Memorial Exhibition,* no. 135; Museum of Art, Carnegie Institute, Pittsburgh, 1983, *Masterpieces of American Drawing and Watercolor,* no. 12; Museum of Art, Carnegie Institute, Pittsburgh, 1985, *American Watercolors and Drawings from the Collection of the Museum of Art, Carnegie Institute* (trav. exh.), no catalogue; The Carnegie Museum of Art, Pittsburgh, 1990, *The Changing Face of America: Selections from the Museum's Collection of American Drawings and Watercolors,* no catalogue.

REMARKS: On July 1, 1946, Burchfield wrote to John O'Connor, assistant director of the Department of Fine Arts, Carnegie Institute, describing this watercolor:

There is no actual scene as depicted in it. It is a concentration of studies, some material from Salem, Ohio, and some from East Liverpool and West Virginia…I guess a little needs to be said about the mood of the picture — early morning after a freezing rain has congealed on everything, bringing down the wires, etc. I have tried to emphasize wetness, half-light, and bleakness.

PROVENANCE: Frank K. M. Rehn, Inc., New York; Mr. and Mrs. James H. Beal, Pittsburgh, 1946.

Gift of Mr. and Mrs. James H. Beal, 46.20.2

House with an Astonished Face

17. CHARLES E. BURCHFIELD
1893–1967

House with an Astonished Face,
1922

Graphite on paper mounted on cardboard
10 7/16 x 16 3/4 in. (26.5 x 42.5 cm)
Signature, date: CEB 1922 (lower left)

REFERENCE: Edith H. Jones, *The Drawings of Charles Burchfield* (New York, 1968), no. 14, n.p.

EXHIBITIONS: Print Club of Cleveland and Cleveland Museum

of Art, 1953, *The Drawings of Charles E. Burchfield,* no. 82; Whitney Museum of American Art, New York, 1956, *Charles Burchfield* (trav. exh.), no. 104; Department of Fine Arts, Carnegie Institute, Pittsburgh, 1957, *Drawings and Watercolors from the Collection of Mr. and Mrs. James H. Beal,* no catalogue.

REMARKS: Shortly before his death, Burchfield wrote of this drawing:

There were, and still are, many houses like this in Buffalo. Depending upon the lighting or time of day, the house shows expressions of various moods. In this drawing the look of astonishment lies within it. There is also a feeling of fright, even melancholy. (quotation from reference cited above)

PROVENANCE: The artist; Mr. and Mrs. James H. Beal, Pittsburgh, Cleveland Museum of Art exhibition, 1953.

Bequest of Mr. and Mrs. James H. Beal, 93.189.9

18. CHARLES E. BURCHFIELD
1893–1967

Young Elms, 1927

Carbon pencil on paper mounted on card
8¹³/₁₆ x 12⅝ in. (22.3 x 32 cm)
Signature, date: CEB 1927 (lower left)

EXHIBITIONS: Print Club of Cleveland and Cleveland Museum

Young Elms

of Art, 1953, *The Drawings of Charles E. Burchfield,* no. 98; Department of Fine Arts, Carnegie Institute, Pittsburgh, 1957, *Drawings and Watercolors from the Collection of Mr. and Mrs. James H. Beal,* no catalogue; The Art Museum, Princeton University, Princeton, N.J., 1981, *Princeton Alumni Collections, Works on Paper,* unnumbered.

PROVENANCE: The artist; Mr. and Mrs. James H. Beal, Pittsburgh, Cleveland Museum of Art exhibition, 1953.

Bequest of Mr. and Mrs. James H. Beal, 93.189.10

19. CHARLES E. BURCHFIELD
1893–1967

Cruciform House in Pennsylvania, 1935

Charcoal and crayon on paper mounted on card
12½ x 17½ in. (31.7 x 44.4 cm)
Signature, date: CEB/1935 (lower right)

REFERENCE: *American Drawings and Watercolors in the Museum of Art, Carnegie Institute,* intro. by Henry Adams (Pittsburgh, 1985), pp. 254–55.

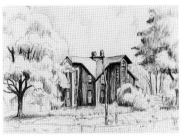
Cruciform House in Pennsylvania

EXHIBITIONS: Print Club of Cleveland and Cleveland Museum of Art, 1953, *The Drawings of Charles E. Burchfield,* no. 110; Department of Fine Arts, Carnegie Institute, Pittsburgh, 1957, *Drawings and Watercolors from the Collection of Mr. and Mrs. James H. Beal,* no catalogue.

PROVENANCE: The artist; Mr. and Mrs. James H. Beal, Pittsburgh, Cleveland Museum of Art exhibition, 1953.

Gift of Mr. and Mrs. James H. Beal, 67.3.2

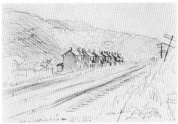
Huddled Houses

20. CHARLES E. BURCHFIELD
1893–1967

Huddled Houses, 1938

Crayon on cardboard
11 x 17 in. (27.9 x 43.2 cm)
Signature, date: CEB 1938 (lower right)
Inscriptions: [illeg.] but hazy with blue sun haze (upper left); rails —

reflect sun at S — reflect bright sky all their length — [illeg.] sunlit areas (lower left); [illeg.] sunshot (center); elder bushes (lower right)

REFERENCE: *American Drawings and Watercolors in the Museum of Art, Carnegie Institute,* intro. by Henry Adams (Pittsburgh, 1985), p. 255.

EXHIBITIONS: Print Club of Cleveland and Cleveland Museum of Art, 1953, *The Drawings of Charles E. Burchfield,* no. 116; Department of Fine Arts, Carnegie Institute, Pittsburgh, 1957, *Drawings and Watercolors from the Collection of Mr. and Mrs. James H. Beal,* no catalogue.

PROVENANCE: The artist; Mr. and Mrs. James H. Beal, Pittsburgh, Cleveland Museum of Art exhibition, 1953.

Gift of Mr. and Mrs. James H. Beal, 67.3.3

21. CHARLES E. BURCHFIELD
1893–1967

The Great Elm, 1939–41

Watercolor on five pieces of paper glued together
33 x 35 in. (83.8 x 88.9 cm)
Signature, date: CEB 1939–41 (lower left)

Color illustration 1.

REFERENCES: Ernest W. Watson, "Charles Burchfield," *American Artist* 6 (May 1942), pp. 5, 7, 9; Charles Burchfield, letter to Mrs. James H. Beal, Dec. 7, 1944, Archives of American Art,

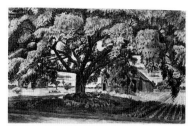

The Great Elm

Washington, D.C.; Munson-Williams-Proctor Institute, *Charles Burchfield, Catalogue of Paintings in Public and Private Collections* (Utica, N.Y., 1970), p. 194; Museum of Art, Carnegie Institute, *Catalogue of the Painting Collection* (Pittsburgh, 1973), p. 31; *American Drawings and Watercolors in the Museum of Art, Carnegie Institute,* intro. by Henry Adams (Pittsburgh, 1985), p. 255.

EXHIBITIONS: Albright Knox Gallery, Buffalo, N.Y., 1944, *Charles Burchfield: A Retrospective Exhibition of Watercolors and Oils 1916–43,* no. 72; Department of Fine Arts, Carnegie Institute, Pittsburgh, 1957, *Drawings and Watercolors from the Collection of Mr. and Mrs. James H. Beal,* no catalogue; Munson-Williams-Proctor Institute, Utica, N.Y., 1970, *The Nature of Charles Burchfield—A Memorial Exhibition,* no. 202; Museum of Art, Carnegie Institute, Pittsburgh, 1985, *American Watercolors and Drawings from the Collection of the Museum of Art, Carnegie Institute* (trav. exh.), no catalogue; The Carnegie Museum of Art, Pittsburgh, 1990, *The Changing Face of America: Selections from the Museum's Collection of*

American Drawings and Watercolors, no catalogue.

REMARKS: Charles Burchfield to Mrs. Beal on Dec. 7, 1944:

I have just heard the thrilling news from Mr. Rehn that my 'Great Elm' has gone into the permanent collection of the Carnegie Institute, and that means you are responsible and have supplied the means…'The Great Elm' is one of which I am particularly fond. In the first place, the tree itself is one of the glories of Western New York, and I felt that what I did of it was so inadequate, but I put into it all I could. I swear it would be impossible to stand under this tree and look in thru its branches without believing in God. Of course one may look at a blade of grass and marvel, but this tree with its unusual flat wide-spreading shape, really forces you to acknowledge the greatness of its creator.

If we ever may have the pleasure of a visit from you here in Gardenville, I should love to take you out there (it is only six miles from our home) and let you stand under it. It is an experience almost as potent as Niagara Falls.

The man who owns the farm on which it grows told me a revealing little incident about it. . . In 1901, it was already famous, and the committee backing the Pan-American Exposition tried to buy the tree from the present owners' grandfather for $50.00. They planned to transplant it, and use it as part of their decorative scheme

and then discard it. Fortunately the grandfather was a thoroughbred, and would not even consider it, though he was far from well-to-do.

PROVENANCE: Frank K. M. Rehn, Inc., New York; Mr. and Mrs. James H. Beal, Pittsburgh, 1944.

Gift of Mr. and Mrs. James H. Beal, 44.9

Maple Tree

22. CHARLES E. BURCHFIELD 1893–1967

Maple Tree, 1944

Crayon on cardboard
17 ¼ x 10 ¾ in. (43.8 x 27.3 cm)
Signature, date: CEB 1944 (lower left)

REFERENCE: *American Drawings and Watercolors in the Museum of Art, Carnegie Institute,* intro. by Henry Adams (Pittsburgh, 1985), p. 255.

EXHIBITIONS: Print Club of Cleveland and Cleveland Museum of Art, 1953, *The Drawings of Charles E. Burchfield,* no. 129; Department of Fine Arts, Carnegie Institute, Pittsburgh, 1957, *Drawings and Watercolors from the Collection of Mr. and Mrs. James H. Beal,* no catalogue.

REMARKS: In 1944 Burchfield enlarged and reworked a painting of 1917 to create the large watercolor *Mid-June* (Albright Knox Gallery, Buffalo, N.Y.). This is one of three detail studies that Burchfield made when redesigning the work.

PROVENANCE: The artist; Mr. and Mrs. James H. Beal, Pittsburgh, Cleveland Museum of Art exhibition, 1953.

Gift of Mr. and Mrs. James H. Beal, 67.3.4

Oak Branch

23. CHARLES E. BURCHFIELD 1893–1967

Oak Branch, 1944

Crayon on two sheets of paper mounted on card
14 x 17 ⅜ in. (35.6 x 44.1 cm)
Signature, date: CEB 1944 (center left)

Inscription: Autumnal Fantasy (lower center)

REFERENCE: *American Drawings and Watercolors in the Museum of Art, Carnegie Institute,* intro. by Henry Adams (Pittsburgh, 1985), p. 255.

EXHIBITIONS: Print Club of Cleveland and Cleveland Museum of Art, 1953, *The Drawings of Charles E. Burchfield,* no. 127; Department of Fine Arts, Carnegie Institute, Pittsburgh, 1957, *Drawings and Watercolors from the Collection of Mr. and Mrs. James H. Beal,* no catalogue.

REMARKS: *Oak Branch* is a detail study for the painting *Autumnal Fantasy* (1916, private collection), which Burchfield enlarged and redesigned in 1944.

PROVENANCE: The artist; Mr. and Mrs. James H. Beal, Pittsburgh, Cleveland Museum of Art exhibition, 1953.

Gift of Mr. and Mrs. James H. Beal, 67.3.6

24. CHARLES E. BURCHFIELD 1893–1967

Sun Glitter, 1945

Watercolor on paper mounted on board
30 x 25 ⅛ in. (76.2 x 63.8 cm)
Signature, date: CEB, 1945 (lower right)

Color illustration 3.

REFERENCES: Charles Burchfield, letter to Mrs. James H. Beal, June

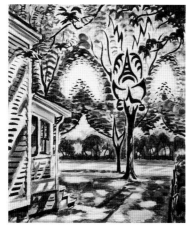

Sun Glitter

21, 1946, Archives of American Art, Washington, D.C.; Charles Burchfield, letter to John O'Connor, July 1, 1946, museum files, The Carnegie Museum of Art, Pittsburgh; Munson-Williams-Proctor Institute, *Charles Burchfield, Catalogue of Paintings in Public and Private Collections* (Utica, N.Y., 1970), p. 214; Museum of Art, Carnegie Institute, *Catalogue of the Painting Collection* (Pittsburgh, 1973), p. 31; *American Drawings and Watercolors in the Museum of Art, Carnegie Institute,* intro. by Henry Adams (Pittsburgh, 1985), p. 256.

EXHIBITIONS: Department of Fine Arts, Carnegie Institute, Pittsburgh, 1957, *Drawings and Watercolors from the Collection of Mr. and Mrs. James H. Beal,* no catalogue; Munson-Williams-Proctor Institute, Utica, N.Y., 1970, *The Nature of Charles Burchfield—A Memorial Exhibition,* no. 216.

REMARKS: Charles Burchfield to Mrs. Beal on June 21, 1946:

Don't let anyone kid you about the title—after all, why not Sea Shells, or Sun Glare or Sun Shimmer or what have you? What's in a name?

PROVENANCE: Frank K. M. Rehn, Inc., New York; Mr. and Mrs. James H. Beal, Pittsburgh, 1946.

Gift of Mr. and Mrs. James H. Beal, 46.20.1

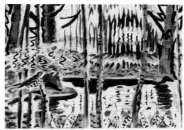

Song of the Wood Thrush

25. CHARLES E. BURCHFIELD
1893–1967

Song of the Wood Thrush, 1950

Watercolor on cardboard
12 x 17 $^{15}/_{16}$ in. (30.5 x 45.5 cm)
Signature, date: C E B 1950 (lower left)

Color illustration 11.

REFERENCES: Charles Burchfield, letter to Mrs. James H. Beal, Jan. 7, 1951, Archives of American Art, Washington, D.C.; Munson-Williams-Proctor Institute, *Charles Burchfield, Catalogue of Paintings in Public and Private Collections* (Utica, N.Y., 1970), p. 238.

EXHIBITIONS: Whitney Museum of American Art, New York, 1956, *Charles Burchfield* (trav. exh.), no. 78; Department of Fine Arts, Carnegie Institute, Pittsburgh, 1957, *Drawings and Watercolors*

from the Collection of Mr. and Mrs. James H. Beal, no catalogue.

REMARKS: Charles Burchfield to Mrs. Beal on Jan. 7, 1951:

I had been painting all day (doing this big one 'The Glory of Spring' which you mentioned). It had been a beautiful rewarding day. As evening came on, I sat at the base of a large tree to eat my lunch. Presently a wood thrush began to sing, to me it is one of the most beautiful woodland songs. For a number of years I have been wanting to do a wood thrush song, and this now seemed to be the moment—Tired out, I had to goad myself to work, but I did so, putting down my feelings regardless of plan or drawing. The picture, a 19 x 40", was not a complete success, although it had in it the elements I was after. So this Fall I got it out to study it, and all at once I saw what it should be and I decided to repaint it on a small scale. And now you have the result.

PROVENANCE: Frank K. M. Rehn, Inc., New York; Mr. and Mrs. James H. Beal, Pittsburgh, 1951.

Bequest of Mr. and Mrs. James H. Beal, 93.189.11

26. JOHN CARROLL
1892–1959

Nude, n.d.

Graphite and ink wash on paper
18 x 11$^{7}/_{8}$ in. (45.7 x 30.1 cm)
Signature: John Carroll (lower right)

Nude

REFERENCE: *American Drawings and Watercolors in the Museum of Art, Carnegie Institute,* intro. by Henry Adams (Pittsburgh, 1985), p. 256.

EXHIBITION: Department of Fine Arts, Carnegie Institute, Pittsburgh, 1957, *Drawings and Watercolors from the Collection of Mr. and Mrs. James H. Beal,* no catalogue.

PROVENANCE: Frank K. M. Rehn, Inc., New York.

Gift of Mr. and Mrs. James H. Beal, 83.62.1

27. CHARLES DEMUTH
1883–1935

White Horse, 1912

Graphite and watercolor on paper
9 ³/₈ x 5 ³/₁₆ in. (23.8 x 13.2 cm)

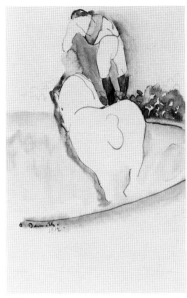

White Horse

Signature, date: C. Demuth 1912 (lower left)

REFERENCES: Richard Weyand, *The Work of Charles Demuth* (Beinecke Library, Yale University, New Haven, Conn.; and private collections), n.d., no. 31; Alvord L. Eiseman, *Catalogue Raisonné of the Complete Works of Charles Demuth* (unpublished), no. 70, 1912; Andrew Ritchie, *Charles Demuth* (New York, 1950), p. 89; Emily Farnham, "Charles Demuth: His Life, Psychology and Works," Ph.D. diss., Ohio State University, Columbus, 1959, vol. 2, p. 441; Alvord L. Eiseman, "A Study of the Development of an Artist: Charles Demuth," Ph.D. diss., New York University, 1976, p. 267; Henry Adams, "The Beal Collection of Watercolors by Charles Demuth," *Carnegie Magazine* 56 (Nov.–Dec. 1983), p. 23.

EXHIBITIONS: Fackenthal Library, Franklin and Marshall College, Lancaster, Pa., 1948, *Twenty-Nine Watercolors by Charles Demuth,* no. 2; Museum of Modern Art, New York, 1950, *Charles Demuth* (trav. exh.), no. 8; Department of Fine Arts, Carnegie Institute, Pittsburgh, 1957, *Drawings and Watercolors from the Collection of Mr. and Mrs. James H. Beal,* no catalogue; Museum of Art, Carnegie Institute, Pittsburgh, 1983–84, *The Beal Collection of Watercolors by Charles Demuth,* no. 2.

PROVENANCE: Robert Locher, Lancaster, Pa., by descent, 1935; Richard Weyand, Lancaster, Pa., by descent, 1946; Mr. and Mrs. James H. Beal, Pittsburgh, 1951.

Bequest of Mr. and Mrs. James H. Beal, 93.189.12

28. CHARLES DEMUTH
1883–1935

Bartender at the Brevoort, c. 1912

Watercolor on paper mounted on cardboard
9 ¹/₄ x 5 ³/₄ in. (22.5 x 14.6 cm)
Inscription: 119/Watercolor by Charles Demuth/ca. 1912 — Inherited by Robert E. Lo [illeg.]/1935 — (on reverse)

Color illustration 22.

REFERENCES: Richard Weyand, *The Work of Charles Demuth* (Beinecke Library, Yale University, New Haven, Conn.; and private collections), n.d., no. 119; Alvord L. Eiseman, *Catalogue*

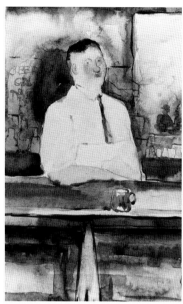

Bartender at the Brevoort

Raisonné of the Complete Works of Charles Demuth (unpublished), no. 63, 1912; Emily Farnham, "Charles Demuth: His Life, Psychology and Works," Ph.D. diss., Ohio State University, Columbus, 1959, vol. 2, pp. 421–22; Emily Farnham, *Charles Demuth, Behind a Laughing Mask* (Norman, Okla., 1971), p. 106; Henry Adams, "The Beal Collection of Watercolors by Charles Demuth," *Carnegie Magazine* 56 (Nov.–Dec. 1983), p. 22.

EXHIBITIONS: Department of Fine Arts, Carnegie Institute, Pittsburgh, 1957, *Drawings and Watercolors from the Collection of Mr. and Mrs. James H. Beal*, no catalogue; Museum of Art, Carnegie Institute, Pittsburgh, 1983–84, *The Beal Collection of Watercolors by Charles Demuth*, no. 12.

REMARKS: During visits to New York, Demuth often stayed at the

Brevoort, a famous Greenwich Village hotel known for its dingy rooms and excellent French cuisine.

PROVENANCE: Robert Locher, Lancaster, Pa., by descent, 1935; Richard Weyand, Lancaster, Pa., by descent, 1946; Durlacher Brothers, New York; Edgar J. Kaufmann, Jr., Pittsburgh, 1956; by gift to Mr. James H. Beal, 1956.

Bequest of Mr. and Mrs. James H. Beal, 93.189.13

29. CHARLES DEMUTH
1883–1935

Two Figures: Turkish Bath, 1915
(Turkish Bath)

Graphite and watercolor on paper
10 1/4 x 8 1/4 in. (26 x 21 cm)
Signature: C. Demuth (lower left)

REFERENCES: Richard Weyand, *The Work of Charles Demuth* (Beinecke Library, Yale University, New Haven, Conn.; and private collections), n.d., no. 150; Alvord L. Eiseman, *Catalogue Raisonné of the Complete Works of Charles Demuth* (unpublished), no. 59, 1915; Emily Farnham, "Charles Demuth: His Life, Psychology and Works," Ph.D. diss., Ohio State University, Columbus, 1959, vol. 2, pp. 465–66; Henry Adams, "The Beal Collection of Watercolors by Charles Demuth," *Carnegie Magazine* 56 (Nov.–Dec. 1983), p. 23.

EXHIBITIONS: Department of Fine Arts, Carnegie Institute, Pittsburgh, 1957, *Drawings and Watercolors*

Two Figures: Turkish Bath

from the Collection of Mr. and Mrs. James H. Beal, no catalogue; Katonah Gallery, Katonah, N.Y., 1964, *Charles Demuth,* no. 2, as *Turkish Bath*; Museum of Art, Carnegie Institute, Pittsburgh, 1983–84, *The Beal Collection of Watercolors by Charles Demuth,* no. 3.

PROVENANCE: Robert Locher, Lancaster, Pa., by descent, 1935; Mr. and Mrs. James H. Beal, Pittsburgh, 1950.

Bequest of Mr. and Mrs. James H. Beal, 93.189.14

30. CHARLES DEMUTH
1883–1935

In Vaudeville: Two Acrobats on Bicycle, 1915–16
(In Vaudeville; In Vaudeville: Bicycle Rider #1; Two Acrobats on Bicycles)

Graphite and watercolor on paper
12 15/16 x 7 15/16 in. (32.8 x 20.1 cm)
Signature: C. Demuth (lower left)

In Vaudeville: Two Acrobats on Bicycle

REFERENCES: Alvord L. Eiseman, *Catalogue Raisonné of the Complete Works of Charles Demuth* (unpublished), no. 54, 1915; Emily Farnham, "Charles Demuth: His Life, Psychology and Works," Ph.D. diss., Ohio State University, Columbus, 1959, vol. 2, p. 456, as *In Vaudeville: Bicycle Rider #1*; Alvord L. Eiseman, "A Study of the Development of an Artist: Charles Demuth," Ph.D. diss., New York University, 1976, pp. 267–68; Henry Adams, "The Beal Collection of Watercolors by Charles Demuth," *Carnegie Magazine* 56 (Nov.–Dec. 1983), p. 25.

EXHIBITIONS: Whitney Museum of American Art, New York, 1937–38, *Charles Demuth Memorial Exhibit,* no. 28, as *In Vaudeville*; Department of Fine Arts, Carnegie Institute, Pittsburgh, 1957, *Drawings and Watercolors*

from the Collection of Mr. and Mrs. James H. Beal, no catalogue; Katonah Gallery, Katonah, N.Y., 1964, *Charles Demuth,* no. 1; Museum of Art, Carnegie Institute, Pittsburgh, 1971–72, *Forerunners of American Abstraction,* no. 3, as *Two Acrobats on Bicycles*; The Art Museum, Princeton University, Princeton, N.J., 1981, *Princeton Alumni Collections, Works on Paper,* unnumbered; Museum of Art, Carnegie Institute, Pittsburgh, 1983–84, *The Beal Collection of Watercolors by Charles Demuth,* no. 6.

PROVENANCE: Daniel Gallery, New York; Thomas H. Russell, Ferargil Gallery, New York; Mrs. Charles H. Russell, Jr., 1939; Frank K. M. Rehn, Inc., New York; Mr. and Mrs. James H. Beal, Pittsburgh, 1950.

Bequest of Mr. and Mrs. James H. Beal, 93.189.17

31. CHARLES DEMUTH
1883–1935

Acrobats: Two Figures Bowing, 1916
(Bowing Acrobats)

Graphite and watercolor on paper mounted on cardboard
7³/₄ x 9³/₄ in. (19.7 x 24.8 cm)
Signature, date: C. Demuth 1916 (lower left)

REFERENCES: Richard Weyand, *The Work of Charles Demuth* (Beinecke Library, Yale University, New Haven, Conn.; and private collections), n.d., no. 904;

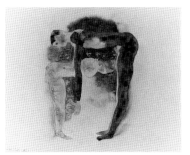

Acrobats: Two Figures Bowing

Alvord L. Eiseman, *Catalogue Raisonné of the Complete Works of Charles Demuth* (unpublished), no. 99, 1916; Emily Farnham, "Charles Demuth: His Life, Psychology and Works," Ph.D. diss., Ohio State University, Columbus, 1959, vol. 2, p. 471, as *Bowing Acrobats*; Henry Adams, "The Beal Collection of Watercolors by Charles Demuth," *Carnegie Magazine* 56 (Nov.–Dec. 1983), p. 24.

EXHIBITIONS: The Print Club, Philadelphia, date unknown; Pennsylvania Museum of Art, Philadelphia, date unknown; Edwin P. Hewitt Gallery, New York, 1949, *Watercolors and Drawings,* no. 2; Department of Fine Arts, Carnegie Institute, Pittsburgh, 1957, *Drawings and Watercolors from the Collection of Mr. and Mrs. James H. Beal,* no catalogue; Katonah Gallery, Katonah, N.Y., 1964, *Charles Demuth,* no. 4; Museum of Art, Carnegie Institute, Pittsburgh, 1971–72, *Forerunners of American Abstraction,* no. 2; Museum of Art, Carnegie Institute, Pittsburgh, 1983–84, *The Beal Collection of Watercolors by Charles Demuth,* no. 5.

PROVENANCE: Daniel Gallery, New York; Mr. and Mrs. Maurice J. Speiser; sale, Parke-Bernet, New York, Jan. 26, 1944, no. 521; Edwin P. Hewitt, New York, 1944; Mr. and Mrs. James H. Beal, Pittsburgh, 1950.

Bequest of Mr. and Mrs. James H. Beal, 93.189.16

Bathers

32. CHARLES DEMUTH
1883–1935

Bathers, c. 1916

Graphite and watercolor on paper
8 ¹/₂ x 11 in. (21.6 x 27.9 cm)
Signature: C. Demuth (lower left)

REFERENCES: Richard Weyand, *The Work of Charles Demuth* (Beinecke Library, Yale University, New Haven, Conn.; and private collections), n.d., no. 82; Alvord L. Eiseman, *Catalogue Raisonné of the Complete Works of Charles Demuth* (unpublished), no. 86, 1916; Emily Farnham, "Charles Demuth: His Life, Psychology and Works," Ph.D. diss., Ohio State University, Columbus, 1959, vol. 2, pp. 468–69; Henry Adams, "The Beal Collection of Watercolors by Charles Demuth,"

Carnegie Magazine 56 (Nov.–Dec. 1983), p. 24.

EXHIBITIONS: Department of Fine Arts, Carnegie Institute, Pittsburgh, 1957, *Drawings and Watercolors from the Collection of Mr. and Mrs. James H. Beal,* no catalogue; Katonah Gallery, Katonah, N.Y., 1964, *Charles Demuth,* no. 3; Museum of Art, Carnegie Institute, Pittsburgh, 1983–84, *The Beal Collection of Watercolors by Charles Demuth,* no. 4.

PROVENANCE: Robert Locher, Lancaster, Pa., by descent, 1935; Mr. and Mrs. James H. Beal, Pittsburgh, 1956.

Bequest of Mr. and Mrs. James H. Beal, 93.189.15

33. CHARLES DEMUTH
1883–1935

Tree, c. 1916 or 1920

Graphite and watercolor on paper
10 ¹/₂ x 7 ⁷/₈ in. (26.7 x 20 cm)
Inscription: a page from Demuth sketchbook, c. 1920 — Bob (on reverse in ink by Robert Locher)

REFERENCES: Alvord L. Eiseman, *Catalogue Raisonné of the Complete Works of Charles Demuth* (unpublished), no. 37, 1916; Emily Farnham, "Charles Demuth: His Life, Psychology and Works," Ph.D. diss., Ohio State University, Columbus, 1959, vol. 2, pp. 744–45; Henry Adams, "The Beal Collection of Watercolors by Charles Demuth,"

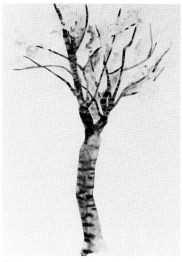
Tree

Carnegie Magazine 56 (Nov.–Dec. 1983), p. 26.

EXHIBITIONS: Department of Fine Arts, Carnegie Institute, Pittsburgh, 1957, *Drawings and Watercolors from the Collection of Mr. and Mrs. James H. Beal,* no catalogue; Museum of Art, Carnegie Institute, Pittsburgh, 1983–84, *The Beal Collection of Watercolors by Charles Demuth,* no. 8.

REMARKS: The inscription on the reverse of the drawing contradicts Eiseman's date of 1916.

PROVENANCE: The artist's mother, Mrs. Augusta W. Demuth, Lancaster, Pa., by descent; by gift to Robert Locher, Lancaster, Pa., 1940; by gift to Mrs. James H. Beal, 1950.

Bequest of Mr. and Mrs. James H. Beal, 93.189.19

Architecture

34. CHARLES DEMUTH
1883–1935

Architecture, 1918
(House, Provincetown)

Graphite and watercolor on paper
14 x 10 in. (35.5 x 25.4 cm)
Signature, date: Demuth 1918
(lower left)

Color illustration 8.

REFERENCES: Richard Weyand,
The Work of Charles Demuth
(Beinecke Library, Yale University, New Haven, Conn.; and private collections), n.d., no. 73;
Alvord L. Eiseman, *Catalogue
Raisonné of the Complete Works of
Charles Demuth* (unpublished),
no. 73, 1918; Emily Farnham,
"Charles Demuth: His Life,
Psychology and Works," Ph.D.
diss., Ohio State University,
Columbus, 1959, vol. 2, pp.
523–24; Henry Adams, "The Beal
Collection of Watercolors by

Charles Demuth," *Carnegie
Magazine* 56 (Nov.–Dec. 1983),
p. 25; Kenneth Neal, in *American
Drawings and Watercolors in the
Museum of Art, Carnegie Institute,*
intro. by Henry Adams (Pittsburgh,
1985), pp. 152–53, 261.

EXHIBITIONS: Museum of Modern
Art, New York, 1950, *Charles
Demuth* (trav. exh.), no. 72;
Department of Fine Arts, Carnegie
Institute, Pittsburgh, 1957,
*Drawings and Watercolors from
the Collection of Mr. and Mrs.
James H. Beal,* no catalogue;
Katonah Gallery, Katonah, N.Y.,
1964, *Charles Demuth,* no. 5;
Museum of Art, Carnegie Institute,
Pittsburgh, 1971–72, *Forerunners
of American Abstraction,* no. 8.;
Museum of Art, Carnegie Institute,
Pittsburgh, 1983–84, *The Beal
Collection of Watercolors by
Charles Demuth,* no. 7.

PROVENANCE: Robert Locher,
Lancaster, Pa., by descent, 1935;
Kraushaar Galleries, Inc., New
York, 1939; Mr. and Mrs. James H.
Beal, Pittsburgh, 1948.

Bequest of Mr. and Mrs. James H.
Beal, 93.189.18

35. CHARLES DEMUTH
1883–1935

White Lilacs, 1923

Graphite and watercolor on paper
13⅝ x 9½ in. (34.6 x 24.1 cm)
Signature, date: C. Demuth 1923
(lower center)

Color illustration 18.

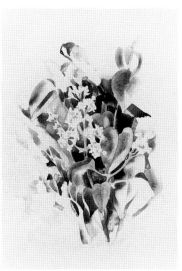

White Lilacs

REFERENCES: Richard Weyand,
The Work of Charles Demuth
(Beinecke Library, Yale University, New Haven, Conn.; and private collections), n.d., no. 71;
Alvord L. Eiseman, *Catalogue
Raisonné of the Complete Works of
Charles Demuth* (unpublished), no.
10, 1923; Emily Farnham, "Charles
Demuth: His Life, Psychology and
Works," Ph.D. diss., Ohio State
University, Columbus, 1959, vol.
2, pp. 586–87; Emily Farnham,
*Charles Demuth, Behind a
Laughing Mask* (Norman, Okla.,
1971), p. 149; Henry Adams, "The
Beal Collection of Watercolors by
Charles Demuth," *Carnegie
Magazine* 56 (Nov.–Dec. 1983),
p. 26.

EXHIBITIONS: Society of the Four
Arts, West Palm Beach, Fla., 1950,
*From the Armory Show to the
Present,* no. 11; Department of
Fine Arts, Carnegie Institute,
Pittsburgh, 1957, *Drawings and*

Watercolors from the Collection of Mr. and Mrs. James H. Beal, no catalogue; Westmoreland County Museum of Art, Greensburg, Pa., 1959, *Flower Paintings,* unnumbered; Katonah Gallery, Katonah, N.Y., 1964, *Charles Demuth,* no. 6; Museum of Art, Carnegie Institute, Pittsburgh, 1983–84, *The Beal Collection of Watercolors by Charles Demuth,* no. 9.

PROVENANCE: Robert Locher, Lancaster, Pa., by descent, 1935; Durlacher Brothers, New York, 1949; Mr. and Mrs. James H. Beal, Pittsburgh, 1954.

Bequest of Mr. and Mrs. James H. Beal, 93.189.20

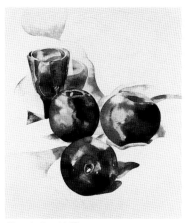

Three Apples with Glass

36. CHARLES DEMUTH
1883–1935

Three Apples with Glass, c. 1925

Graphite and watercolor on paper 11³/₄ x 10¹/₁₆ in. (29.8 x 25.5 cm)

Color illustration 21.

REFERENCES: Richard Weyand, *The Work of Charles Demuth*

(Beinecke Library, Yale University, New Haven, Conn.; and private collections), n.d., no. 237; Alvord L. Eiseman, *Catalogue Raisonné of the Complete Works of Charles Demuth* (unpublished), no. 24, 1925; Emily Farnham, "Charles Demuth: His Life, Psychology and Works," Ph.D. diss., Ohio State University, Columbus, 1959, vol. 2, p. 602; Henry Adams, "The Beal Collection of Watercolors by Charles Demuth," *Carnegie Magazine* 56 (Nov.–Dec. 1983), p. 27.

EXHIBITIONS: Department of Fine Arts, Carnegie Institute, Pittsburgh, 1957, *Drawings and Watercolors from the Collection of Mr. and Mrs. James H. Beal,* no catalogue; Museum of Art, Carnegie Institute, Pittsburgh, 1971–72, *Forerunners of American Abstraction,* no. 15; The Art Museum, Princeton University, Princeton, N.J., 1981, *Princeton Alumni Collections, Works on Paper,* unnumbered; Museum of Art, Carnegie Institute, Pittsburgh, 1983–84, *The Beal Collection of Watercolors by Charles Demuth,* no. 10.

REMARKS: Demuth painted two similar versions of this subject: one belongs to the Sheldon Memorial Gallery, University of Nebraska; the other is in the collection of the Art Institute of Chicago. The Chicago piece is inscribed "Feb 1925...Lancaster Pa.," suggesting the date and place where this watercolor may have been executed.

PROVENANCE: Robert Locher, Lancaster, Pa., by descent, 1935; Mr. and Mrs. James H. Beal, Pittsburgh, 1956.

Bequest of Mr. and Mrs. James H. Beal, 93.189.21

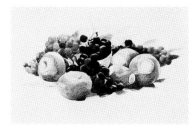

Grapes and Turnips

37. CHARLES DEMUTH
1883–1935

Grapes and Turnips, 1926

Graphite and watercolor on paper 12³/₄ x 17¹/₂ in. (32.4 x 44.4 cm) Signature, date: C. Demuth 1926 (center right)

Color illustration 4.

REFERENCES: Richard Weyand, *The Work of Charles Demuth* (Beinecke Library, Yale University, New Haven, Conn.; and private collections), n.d., no. 373; Alvord L. Eiseman, *Catalogue Raisonné of the Complete Works of Charles Demuth* (unpublished), no. 5, 1926; Emily Farnham, "Charles Demuth: His Life, Psychology and Works," Ph.D. diss., Ohio State University, Columbus, 1959, vol. 2, p. 606; Henry Adams, "The Beal Collection of Watercolors by Charles Demuth," *Carnegie Magazine* 56 (Nov.–Dec. 1983), p. 21; Kenneth Neal, in *American*

Drawings and Watercolors in the Museum of Art, Carnegie Institute, intro. by Henry Adams (Pittsburgh, 1985), pp. 152–54, 261.

EXHIBITIONS: Whitney Museum of American Art, New York, 1937–38, *Charles Demuth Memorial Exhibit,* no. 39; Department of Fine Arts, Carnegie Institute, Pittsburgh, 1957, *Drawings and Watercolors from the Collection of Mr. and Mrs. James H. Beal,* no catalogue; Museum of Art, Carnegie Institute, Pittsburgh, 1971–72, *Forerunners of American Abstraction,* no. 16; Museum of Art, Carnegie Institute, Pittsburgh, 1983–84, *The Beal Collection of Watercolors by Charles Demuth,* no. 11.

PROVENANCE: Philip L. Goodwin, New York, 1937–38; The Downtown Gallery, Inc., New York; Mr. and Mrs. James H. Beal, Pittsburgh, 1947.

Bequest of Mr. and Mrs. James H. Beal, 93.189.22

38. CHARLES DEMUTH
1883–1935

The Artist on the Beach at Provincetown, 1934
(Man Painting, Provincetown)

Graphite and watercolor on paper
8 7/16 x 11 in. (21.4 x 27.9 cm)
Signature, date: C. Demuth '34 (lower left)

Color illustration 24.

REFERENCES: Richard Weyand, *The Work of Charles Demuth*

The Artist on the Beach at Provincetown

(Beinecke Library, Yale University, New Haven, Conn.; and private collections), n.d., no. 54; Alvord L. Eiseman, *Catalogue Raisonné of the Complete Works of Charles Demuth* (unpublished), no. 5, 1934; Emily Farnham, "Charles Demuth: His Life, Psychology and Works," Ph.D. diss., Ohio State University, Columbus, 1959, vol. 2, p. 669, as *Man Painting, Provincetown*; Henry Adams, "The Beal Collection of Watercolors by Charles Demuth," *Carnegie Magazine* 56 (Nov.–Dec. 1983), p. 20; Kenneth Neal, in *American Drawings and Watercolors in the Museum of Art, Carnegie Institute,* intro. by Henry Adams (Pittsburgh, 1985), pp. 152–54, 261.

EXHIBITIONS: Department of Fine Arts, Carnegie Institute, Pittsburgh, 1957, *Drawings and Watercolors from the Collection of Mr. and Mrs. James H. Beal,* no catalogue; Museum of Art, Ogunquit, Me., 1960, *Americans of Our Times,* no. 20; Department of Fine Arts, Carnegie Institute, Pittsburgh, 1963, *Art Since 1900 — Privately Owned in the Pittsburgh Area,* no catalogue; Katonah Gallery, Katonah, N.Y., 1964, *Charles Demuth,* no. 7;

Museum of Art, Carnegie Institute, Pittsburgh, 1971–72, *Forerunners of American Abstraction,* no. 19; The Art Museum, Princeton University, Princeton, N.J., 1981, *Princeton Alumni Collections, Works on Paper,* unnumbered; Museum of Art, Carnegie Institute, Pittsburgh, 1983–84, *The Beal Collection of Watercolors by Charles Demuth,* no. 12.

PROVENANCE: Robert Locher, Lancaster, Pa., by descent, 1935; Mr. Savage, 1935; Richard Weyand, Lancaster, Pa., by 1956; Maynard Walker Gallery, New York; Mr. and Mrs. James H. Beal, Pittsburgh, 1960.

Bequest of Mr. and Mrs. James H. Beal, 93.189.23

Highbridge

39. PRESTON DICKINSON
1891–1930

Highbridge, c. 1922

Graphite, pen and ink, crayon, charcoal, watercolor, and pastel on paper
18 x 18 in. (45.7 x 45.7 cm)

Color illustration 17.

EXHIBITIONS: American Art Association, New York, 1929, *Environs of New York,* probably no. 416; Department of Fine Arts, Carnegie Institute, Pittsburgh, 1957, *Drawings and Watercolors from the Collection of Mr. and Mrs. James H. Beal,* no catalogue.

REMARKS: A crayon and pastel sketch of the same subject is on the reverse.

PROVENANCE: Arthur B. Davies, New York, sale of his estate, American Art Association, New York, April 17, 1929, probably no. 416; Frank K. M. Rehn, Inc., New York; Mr. and Mrs. James H. Beal, Pittsburgh, 1954.

Bequest of Mr. and Mrs. James H. Beal, 93.189.24

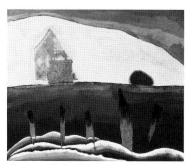

Huntington Harbor II

40. ARTHUR G. DOVE
1880–1946

Huntington Harbor II, c. 1926

Sand, cloth, wood chips, and oil on metal
10 x 12 1/4 in. (25.4 x 31.1 cm)

Color illustration 20.

REFERENCES: Frederick S. Wight, *Arthur G. Dove* (Berkeley and Los Angeles, Calif., 1958), pp. 47, 52; Sherrye Cohn, "Arthur Dove, Nature as Symbol," Ph.D. diss., Washington University, St. Louis, Mo., 1982, p. 102; Ann Lee Morgan, *Arthur Dove, Life and Work* (Newark, N.J., 1984), p. 148.

EXHIBITIONS: Intimate Gallery, New York, 1927, no. 8; Downtown Gallery, New York, 1955, *Collages—Dove,* no. 12; Department of Fine Arts, Carnegie Institute, Pittsburgh, 1957, *Drawings and Watercolors from the Collection of Mr. and Mrs. James H. Beal,* no catalogue; Whitney Museum of American Art, New York, 1958, *Arthur G. Dove Retrospective Exhibition* (trav. exh.), no. 17; University of Maryland Art Gallery, College Park, 1967, *Arthur Dove: The Years of Collage* (trav. exh.), no. 18; Museum of Art, Carnegie Institute, Pittsburgh, 1971–72, *Forerunners of American Abstraction,* no. 22.

REMARKS: *Huntington Harbor II* is one of a pair of assemblages Dove created on the same theme. The other example, *Huntington Harbor I* (The Phillips Collection, Washington, D.C.), is dated July 1926 on the reverse, providing a likely date for *Huntington Harbor II.*

PROVENANCE: Estate of the artist; The Downtown Gallery, Inc., New York; Mr. and Mrs. James H. Beal, Pittsburgh, 1955.

Bequest of Mr. and Mrs. James H. Beal, 93.189.25

Tree Forms

41. ARTHUR G. DOVE
1880–1946

Tree Forms, c. 1928

Pastel and tempera on plywood
25 1/4 x 29 3/4 in. (64.1 x 75.6 cm)

Color illustration 5.

REFERENCES: Fred A. Myers, "Dove: *Tree Forms,*" *Carnegie Magazine* 41 (Feb. 1967), p. 69; Ann Lee Morgan, *Arthur Dove: Life and Work* (Newark, N.J., 1984), p. 165; Elizabeth A. Prelinger, in Museum of Art, Carnegie Institute, *Collection Handbook* (Pittsburgh, 1985), p. 246; Lauretta Dimmick and Diana Strazdes, in *American Paintings and Sculpture to 1945 in The Carnegie Museum of Art,* by Diana Strazdes, et al. (New York, 1992), pp. 171–72.

EXHIBITIONS: Downtown Gallery, New York, 1947, *Dove Retrospective Exhibition,* no. 8; Whitney Museum of American Art, New York, 1958, *Arthur G. Dove Retrospective Exhibition,* no. 22; Museum of Art, Carnegie Institute, Pittsburgh, 1971–72, *Forerunners of American Abstraction,* no. 23.

PROVENANCE: Estate of the artist; The Downtown Gallery, Inc., New York, 1946; Mr. and Mrs. James H. Beal, Pittsburgh, 1947.

Gift of Mr. and Mrs. James H. Beal, 60.3.2

Falling Shed Roof

42. ARTHUR G. DOVE
1880–1946

Falling Shed Roof, 1934

Watercolor on paper mounted on board
4 ⁷/₈ x 6 ⁷/₈ in. (12.4 x 17.4 cm)
Signature: Dove (bottom center)

EXHIBITION: Department of Fine Arts, Carnegie Institute, Pittsburgh, 1957, *Drawings and Watercolors from the Collection of Mr. and Mrs. James H. Beal,* no catalogue.

PROVENANCE: An American Place, New York; The Downtown Gallery, Inc., New York; Mr. and Mrs. James H. Beal, Pittsburgh, 1949.

Bequest of Mr. and Mrs. James H. Beal, 93.189.27

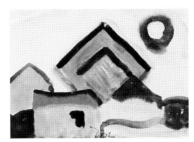

Barns

43. ARTHUR G. DOVE
1880–1946

Barns, 1935

Watercolor on paper mounted on cardboard
5 ¹/₁₆ x 7 in. (12.8 x 17.8 cm)
Signature: Dove (bottom center)

EXHIBITION: Department of Fine Arts, Carnegie Institute, Pittsburgh, 1957, *Drawings and Watercolors from the Collection of Mr. and Mrs. James H. Beal,* no catalogue.

PROVENANCE: The Downtown Gallery, Inc., New York; Mr. and Mrs. James H. Beal, Pittsburgh, 1949.

Bequest of Mr. and Mrs. James H. Beal, 93.189.29

44. ARTHUR G. DOVE
1880–1946

Canandaigua Outlet, Oaks Corner, 1937

Watercolor on paper mounted on board
5 ¹/₂ x 9 in. (14 x 22.9 cm)
Signature: Dove (bottom center)

REFERENCE: Margaret Breuning, "Dove Makes Posthumous Watercolor Debut at Downtown

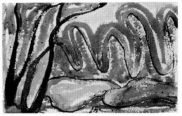

Canandaigua Outlet, Oaks Corner

Gallery," *Art Digest* 23 (May 15, 1949), p. 13 (illus.).

EXHIBITIONS: An American Place, New York, 1937; Museum of Fine Arts, Boston, 1939, *Ten American Watercolor Painters,* no. 18; Department of Fine Arts, Carnegie Institute, Pittsburgh, 1957, *Drawings and Watercolors from the Collection of Mr. and Mrs. James H. Beal,* no catalogue; Museum of Art, Carnegie Institute, Pittsburgh, 1971–72, *Forerunners of American Abstraction,* no. 35.

PROVENANCE: An American Place, New York, 1937; The Downtown Gallery, Inc., New York; Mr. and Mrs. James H. Beal, Pittsburgh, 1949.

Bequest of Mr. and Mrs. James H. Beal, 93.189.26

45. ARTHUR G. DOVE
1880–1946

A Barn Here and a Tree There, 1940

Watercolor on paper mounted on board
4 ⁷/₈ x 6 ⁷/₈ in. (12.4 x 17.4 cm)
Signature: Dove (bottom center)

EXHIBITIONS: Department of Fine Arts, Carnegie Institute, Pittsburgh,

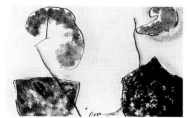

A Barn Here and a Tree There

1957, *Drawings and Watercolors from the Collection of Mr. and Mrs. James H. Beal,* no catalogue; Museum of Art, Carnegie Institute, Pittsburgh, 1971–72, *Forerunners of American Abstraction,* no. 37.

PROVENANCE: An American Place, New York; The Downtown Gallery, Inc., New York; Mr. and Mrs. James H. Beal, Pittsburgh, 1949.

Bequest of Mr. and Mrs. James H. Beal, 93.189.28

46. THOMAS EAKINS
1844–1916

Study for "Salutat," 1898
(Study)

Oil on canvas
20 ⅛ x 16 ⅛ in. (51.1 x 40.9 cm)
Inscription: Dextra Victrice/ Conclamantes/Salutat/To his friend/Sadakichi Hartmann/ Thomas Eakins (on reverse, in the artist's hand)

REFERENCES: Lloyd Goodrich, *Thomas Eakins: His Life and Work* (New York, 1933), p. 189, as *Study;* Lloyd Goodrich, *Thomas Eakins* (Washington, D.C., 1982), vol. 2, pp. 152, 155; Diana Strazdes, "Thomas Eakins at The Carnegie: Private Vision, Public

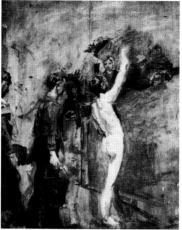

Study for "Salutat"

Enigma," *Carnegie Magazine* 59 (Jan.–Feb., 1988), pp. 27–28; Diana Strazdes, in *American Paintings and Sculpture to 1945 in The Carnegie Museum of Art,* by Diana Strazdes, et al. (New York, 1992), pp. 179–81.

EXHIBITIONS: Department of Fine Arts, Carnegie Institute, Pittsburgh, 1960, *Promised or Given,* no catalogue; National Gallery of Art, Washington, D.C., 1961, *Thomas Eakins, A Retrospective Exhibition* (trav. exh.), no. 68; Whitney Museum of American Art, New York, 1970, *Thomas Eakins Retrospective Exhibition,* no. 69; The Art Museum, Princeton University, Princeton, N.J., 1972, *European and American Art from Princeton Alumni Collections,* no. 38; Museum of Art, Carnegie Institute, Pittsburgh, 1974–75, *Celebration,* no. 24; Butler Institute of American Art, Youngstown, Ohio, 1992, *The Artist at Ringside* (trav. exh.), unnumbered.

PROVENANCE: Sadakichi Hartmann, New York, c. 1898; Mrs. Emil Carlsen, Falls Village, Conn., by 1933; Maynard Walker Gallery, New York, by 1958; Mr. and Mrs. James H. Beal, Pittsburgh, 1958.

Gift of Mr. and Mrs. James H. Beal, 81.54.1

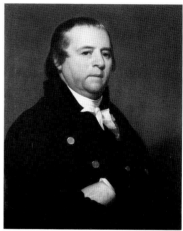

Portrait of a Man

47. JACOB EICHHOLTZ
1776–1842

Portrait of a Man, 1815

Oil on canvas
29 x 24 ⅛ in. (73.7 x 61.3 cm)
Signature, date: Eichholtz/1815 (on reverse, now covered by relining)

REFERENCES: Rebecca J. Beal, *Jacob Eichholtz, 1776–1842: Portrait Painter of Pennsylvania* (Philadelphia, 1969), p. 195; Kenneth Neal, in *American Paintings and Sculpture to 1945 in The Carnegie Museum of Art,* by Diana Strazdes, et al. (New York, 1992), pp. 182–83.

Bouquet

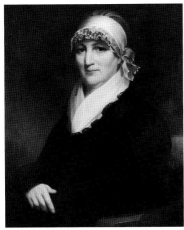
Portrait of a Woman

48. JACOB EICHHOLTZ
1776–1842

Portrait of a Woman, 1815

Oil on canvas
29 x 24 ¹/₈ in. (73.7 x 61.3 cm)

REFERENCES: Rebecca J. Beal, *Jacob Eichholtz, 1776–1842: Portrait Painter of Pennsylvania* (Philadelphia, 1969), pp. 196–97; Kenneth Neal, in *American Paintings and Sculpture to 1945 in The Carnegie Museum of Art,* by Diana Strazdes, et al. (New York, 1992), pp. 182–83.

Luminosity

49. LYONEL FEININGER
1871–1956

Luminosity, 1948

Graphite, ink, and watercolor on paper
12 ³/₈ x 18 ⁷/₈ in. (31.4 x 48 cm)
Signature: Feininger (lower left)
Inscription: 28.vi.48. (lower right); Luminosity (center)

Color illustration 12.

EXHIBITION: Curt Valentin Gallery, New York, 1952, *Lyonel Feininger,* no. 35.

PROVENANCE: Buchholz/Curt Valentin Gallery, New York, by 1950; Mr. and Mrs. James H. Beal, Pittsburgh, 1950.

Bequest of Mr. and Mrs. James H. Beal, 93.189.30

50. MORRIS GRAVES
b. 1910

Bouquet, c. 1950

Tempera or casein on paper
20 ³/₄ x 15 ³/₄ in. (52.7 x 40 cm)
Signature: M Graves (lower right)

EXHIBITIONS: Whitney Museum of American Art, New York, 1950, *Annual Exhibition of Contemporary American Sculpture, Watercolors and Drawings,* no. 98; Department of Fine Arts, Carnegie Institute, Pittsburgh, 1957, *Drawings and Watercolors from the Collection of Mr. and Mrs. James H. Beal,* no catalogue; Department of Fine Arts, Carnegie Institute, Pittsburgh, 1963, *Art Since 1900—Privately Owned in the Pittsburgh Area,* no catalogue.

Bequest of Mr. and Mrs. James H. Beal, 93.189.32

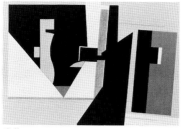

Collage

51. BALCOMB GREENE
1904–1990

Collage, 1936

Paper mounted on cardboard
9³/₄ x 14⁹/₁₆ in. (24.8 x 36.9 cm)
Signature, date: Balcomb Greene
'36 (lower right)

REFERENCE: *American Drawings
and Watercolors in the Museum of
Art, Carnegie Institute,* intro. by
Henry Adams (Pittsburgh, 1985),
p. 256.

EXHIBITION: The American
Federation of Arts, New York,
1961, *Balcomb Greene Retro-
spective Exhibition* (trav. exh.),
no. 2.

PROVENANCE: Mr. and Mrs.
James H. Beal, Pittsburgh, at the
Whitney Museum of American Art
venue of The American Federation
of Arts exhibition, 1961.

Gift of Mrs. James H. Beal, 62.27

52. MARSDEN HARTLEY
1877–1943

***Carros—Looking Toward the
Italian Alps,*** 1927

Graphite on paper
19 x 24 in. (48.3 x 61 cm)

Carros — Looking Toward the Italian Alps

Inscription: Carros/Vue vers des
Alpes Italiens (lower left)

PROVENANCE: Estate of the artist;
Babcock Galleries, New York,
1959; Mr. and Mrs. James H. Beal,
Pittsburgh, 1962.

Bequest of Mr. and Mrs. James H.
Beal, 93.189.34

53. MARSDEN HARTLEY
1877–1943

Garmisch-Partenkirchen,
c. 1933–34

Oil on board
29¹/₂ x 18¹/₄ in. (74.9 x 46.3 cm)
Signature: Marsden Hartley (on
reverse)
Inscription: Waxenstein/Garmisch-
Partenkirchen/Bavaria (on reverse)

Color illustration 13.

REFERENCES: Whitney Museum of
American Art, *Marsden Hartley*
(New York, 1980), p. 95; "Letters
from Germany 1933-1938,"
Archives of American Art Journal
25, nos. 1 and 2 (1985), pp. 3–28;
Gail Scott, *Marsden Hartley* (New
York, 1988), p. 101; Diana
Strazdes and Laura Meixner, in
American Paintings and Sculpture

Garmisch-Partenkirchen

*to 1945 in The Carnegie Museum
of Art,* by Diana Strazdes, et al.
(New York, 1992), pp. 229–30.

EXHIBITIONS: Bertha Schaefer
Gallery, New York, 1950,
*Hartley—Maurer, Contempor-
aneous Paintings,* no. 1; Mansfield
Art Center, Ohio, 1981, *The
American Landscape,* no. 38;
Emerson Gallery, Hamilton
College, Clinton, N.Y., 1989,
Marsden Hartley in Bavaria (trav.
exh.), no. 11.

PROVENANCE: Alzira Peirce,
Bangor, Me., c. 1939–40; Bertha
Schaefer Gallery, New York, by
1950; Mr. and Mrs. James H. Beal,
Pittsburgh, 1951.

Gift of Mr. and Mrs. James H.
Beal, 59.1

Robin

54. MARSDEN HARTLEY
1877–1943

Robin, c. 1940–41

12 x 16 in. (30.5 x 40.6 cm)
Oil on board

REMARKS: One of a group of paintings of dead birds created around 1940–43.

PROVENANCE: Paul Rosenberg & Co., New York.

Bequest of Mr. and Mrs. James H. Beal, 93.189.33

55. WINSLOW HOMER
1836–1910

The Sloop Kulinda, c. 1880

Watercolor on paper
16 ½ x 11 ⅝ in. (41.9 x 29.5 cm)
Signature: Winslow Homer (lower left)

REFERENCES: Information concerning the provenance and exhibition record of this watercolor cour-

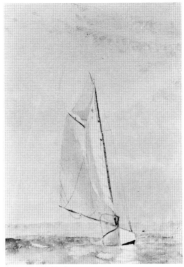

The Sloop Kulinda

tesy of *Manuscript Catalogue Raisonné of the Works of Winslow Homer* by Lloyd Goodrich, courtesy of the City University of New York, Lloyd Goodrich and Edith Havens Goodrich, Whitney Museum of American Art Record of the Works of Winslow Homer.

EXHIBITIONS: Maynard Walker Gallery, New York, 1953, *Early Winslow Homer,* no. 12; Department of Fine Arts, Carnegie Institute, Pittsburgh, 1957, *Drawings and Watercolors from the Collection of Mr. and Mrs. James H. Beal,* no catalogue.

REMARKS: This watercolor was painted as a personal gift for George J. Marsh, owner of the yacht *Kulinda,* who lived in Annisquam, Massachusetts, and was treasurer of the Cape Ann Savings Bank in Gloucester.

PROVENANCE: George J. Marsh, Annisquam, Mass.; Cape Ann

Savings Bank, Gloucester, Mass.; Morris H. Pancoast, Rockport, Mass.; Frank K. M. Rehn, Inc., New York, c. 1930; Mr. and Mrs. James H. Beal, Pittsburgh, 1951 or 1952.

Bequest of Mr. and Mrs. James H. Beal, 93.189.35

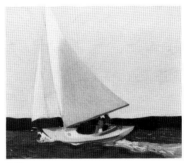

Sailing

56. EDWARD HOPPER
1882–1967

Sailing, c. 1911
(The Sailboat)

Oil on canvas
24 x 29 in. (61 x 73.7 cm)
Signature: E. Hopper (lower left)

Color illustration 14.

REFERENCES: "Edward Hopper: A Lucid Portfolio of Victorian Houses, Railway Scenes, By a Top Notch American Realist," *Pittsburgh Bulletin Index,* Mar. 18, 1937, p. 19; "Carnegie Traces Hopper's Rise to Fame," *Art Digest* 2 (Apr. 1937), p. 14, as *The Sailboat*; Suzanne Burrey, "Edward Hopper: The Emptying Spaces," *Art Digest* 29 (Apr. 1955), p. 9; L. Cooke, "Paintings by Edward Hopper," *America Illustrated* 32 (July 23, 1958), n.p.;

Milton W. Brown, *The Story of the Armory Show* (New York, 1963), pp. 251, 313; review of exhibition at the Munson-Williams-Proctor Institute, Utica, N.Y., "The Current Scene," *Arts* 37 (Feb. 1963), p. 20; G. Nachman, "Closeup: Artist at 82," *New York Post,* Nov. 27, 1964, p. 5; Brian O'Doherty, "Portrait: Edward Hopper," *Art in America* 52 (Dec. 1964), p. 73; Barbara Rose, *American Art Since 1900 — A Critical History* (New York, 1967), p. 124; Lloyd Goodrich, *Edward Hopper* (New York, 1971), pp. 28, 167; James R. Mellow, "The World of Edward Hopper," *New York Times Magazine,* Sept. 5, 1971, p. 16; Brian O'Doherty, *American Masters: The Voice and the Myth* (New York, 1973); *On View: A Guide to Museum and Gallery Acquisitions in Great Britain and America,* 1974 Edition, vol. 8, p. 91; Herdis B. Teilman, "Art in Residence," *Carnegie Magazine* 47 (Nov. 1973), p. 364; David G. Wilkins, "The American Painting Collection at the Sarah Scaife Gallery, Carnegie Institute," *American Art Review* 2 (Mar.–Apr. 1975), pp. 100–01, 108; Lloyd Goodrich, *Edward Hopper* (New York, 1976), p. 19; N. Heiler and J. Williams, "Edward Hopper, Alone in America," *American Artist* 40 (Jan. 1976), p. 72; Barbara Rose, *American Painting: The Twentieth Century* (New York, 1977), p. 46; Gail Levin, *Edward Hopper: The Complete Prints* (New York, 1979), pp. 3–4; Gail Levin, *Edward Hopper: The Art and the Artist* (New York, 1980), pp. 28–29; Donald Miller, "X-Ray of Painting Yields Artist's Self-Portrait," *Pittsburgh Post Gazette,* Dec. 30, 1980; Donald Miller, "Hopper Art Stirs Debate," *Pittsburgh Post Gazette,* Jan. 1, 1981, p. 34; David G. Wilkins, "Edward Hopper's Hidden Self-Portrait," *Carnegie Magazine* 55 (Mar. 1981), pp. 4–6; Charles W. Millard, "Edward Hopper," *Hudson Review* 34 (Oct. 1, 1981), p. 392; Ellen S. Jacobowitz and George H. Marcus, *American Graphics, 1860–1940* (Philadelphia, 1982), p. 49; S. Lane Faison, Jr., *The New England Eye: Master American Paintings from the New England School, College and University Collections* (Williamstown, Mass., 1983), pp. 40–42; Frank Webb, *Watercolor Energies* (Fairfield, Conn., 1983), p. 21; Mike Venezia, *Edward Hopper* (Chicago, 1990), p. 18; Hubert B. Ellert, *Edward Hopper* (Hamburg, 1992), p. 14; Peggy Roalf, *Seascapes* (New York, 1992), p. 36; Laura Meixner, in *American Paintings and Sculpture to 1945 in The Carnegie Museum of Art,* by Diana Strazdes, et al. (New York, 1992), pp. 268–70.

EXHIBITIONS: MacDowell Club of New York, 1912, *Exhibition of Paintings,* no. 37; American Association of Painters and Sculptors, Armory of the Sixty-ninth Regiment, New York, 1913, *International Exhibition of Modern Art* (trav. exh.), no. 751; American Academy of Arts and Letters and National Institute of Arts and Letters, New York, 1955, *An Exhibition of Paintings and Sculpture Commemorating the Armory Show of 1913 and the First Exhibition of the Society of Independent Artists in 1917 with Works by Members Who Exhibited There,* no. 2; Mead Art Building, Amherst College, Amherst, Mass., 1958, *The 1913 Armory Show in Retrospect,* no. 23; Munson-Williams-Proctor Institute, Utica, N.Y., 1963, *1913 Armory Show: Fiftieth Anniversary Exhibition, 1963* (trav. exh.), no. 751; Pennsylvania Academy of the Fine Arts, Philadelphia, 1971, *Edward Hopper 1882–1967: Oils, Watercolors, Etchings,* unnumbered; Museum of Art, Carnegie Institute, Pittsburgh, 1973–74, *Art in Residence: Art Privately Owned in the Pittsburgh Area,* no catalogue; Virginia Museum of Fine Arts, Richmond, 1976, *American Marine Painting* (trav. exh.), no. 58; Whitney Museum of American Art, New York, 1980–81, *Edward Hopper: The Art and the Artist,* unnumbered.

PROVENANCE: Thomas F. Vietor, 1913; Henry E. Butler, Rumson, N.J.; Edward A. Early, Rumson, N.J.; Frank K. M. Rehn, Inc., New York, 1952; Mr. and Mrs. James H. Beal, Pittsburgh, 1952.

Gift of Mr. and Mrs. James H. Beal in honor of the Sarah Scaife Gallery, 72.43

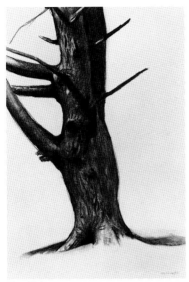

Tree, Maine

57. EDWARD HOPPER
1882–1967

Tree, Maine, 1925–30

Charcoal on paper
22 x 15 in. (56 x 38 cm)
Signature: Edward Hopper (lower right)

EXHIBITIONS: Whitney Museum of American Art, New York, 1950, *Edward Hopper Retrospective Exhibition,* no. 140; Whitney Museum of American Art, New York, 1964, *Edward Hopper,* no. 152.

PROVENANCE: Frank K. M. Rehn, Inc., New York; Mr. and Mrs. James H. Beal, Pittsburgh, 1953.

Gift of the Estate of Mr. and Mrs. James H. Beal, 93.189.38

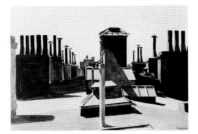

Roofs, Washington Square

58. EDWARD HOPPER
1882–1967

Roofs, Washington Square, 1926

Watercolor over charcoal on paper
13 7/8 x 19 7/8 in. (35.2 x 50.5 cm)
Signature, inscription: Edward Hopper, New York (lower right)

Color illustration 19.

REFERENCE: Lloyd Goodrich, *Edward Hopper* (New York, 1971), illus. p. 86.

EXHIBITIONS: Museum of Modern Art, New York, 1933, *Edward Hopper Retrospective Exhibition,* no. 41; Department of Fine Arts, Carnegie Institute, Pittsburgh, 1937, *Edward Hopper, An Exhibition of Paintings, Watercolors and Etchings,* no. 86; Museum of Modern Art, New York, and Musée du Jeu de Paume, Paris, 1938, *Trois Siècles d'Art aux États Unis,* no. 93; Art Institute of Chicago, 1939, *18th International Exhibition of Watercolors,* no. 339; Whitney Museum of American Art, New York, 1941, *This is our City,* no. 108; Whitney Museum of American Art, New York, 1950, *Edward Hopper Retrospective Exhibition* (trav. exh.), no. 87; Department of Fine Arts, Carnegie

Institute, Pittsburgh, 1957, *Drawings and Watercolors from the Collection of Mr. and Mrs. James H. Beal,* no catalogue; Currier Gallery of Art, Manchester, N.H., 1959, *Watercolors by Edward Hopper* (trav. exh.), no. 6; Whitney Museum of American Art, New York, 1964, *Edward Hopper* (trav. exh.), no. 91.

PROVENANCE: Frank K. M. Rehn, Inc., New York; Mr. and Mrs. James H. Beal, Pittsburgh, 1954.

Bequest of Mr. and Mrs. James H. Beal, 93.189.36

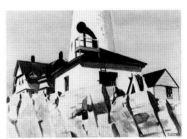

Rock Pedestal, Portland Head

59. EDWARD HOPPER
1882–1967

Rock Pedestal, Portland Head, 1927

Watercolor over charcoal on paper
14 x 19 7/8 in. (35.6 x 50.5 cm)
Signature, inscription: Edward Hopper Portland Head (lower right)

Color illustration 16.

REFERENCE: Lloyd Goodrich, *Edward Hopper* (New York, 1971), illus. p. 191.

EXHIBITIONS: Farnsworth Art Museum, Wellesley College, Wellesley, Mass., 1949, *Masters of American Watercolor,* no catalogue;

Whitney Museum of American Art, New York, 1950, *Edward Hopper Retrospective Exhibition* (trav. exh.), no. 96; Currier Gallery of Art, Manchester, N.H., 1959, *Watercolors by Edward Hopper* (trav. exh.), no. 12; Department of Fine Arts, Carnegie Institute, Pittsburgh, 1957, *Drawings and Watercolors from the Collection of Mr. and Mrs. James H. Beal,* no catalogue; University of Arizona Museum of Art, Tucson, 1963, *Edward Hopper,* no. 17; The Art Museum, Princeton University, Princeton, N.J., 1981, *Princeton Alumni Collections, Works on Paper,* unnumbered.

PROVENANCE: Frank K. M. Rehn, Inc., New York; Mr. and Mrs. James H. Beal, Pittsburgh, 1954.

Bequest of Mr. and Mrs. James H. Beal, 93.189.37

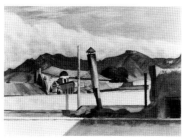

Saltillo Rooftops

60. EDWARD HOPPER
1882–1967

Saltillo Rooftops, 1943

Graphite, watercolor, and gouache on paper
21 1/2 x 29 5/8 in. (54.6 x 75.2 cm)
Signature: Edward Hopper (lower right)

Color illustration 6.

REFERENCES: "The Passing Shows —Edward Hopper," *Art News* 42 (Dec. 15–31, 1943), pp. 15, 30; Lloyd Goodrich, *Edward Hopper* (Harmondsworth, England, 1949), plate 25; Lloyd Goodrich, *Edward Hopper* (New York, 1971), illus. p. 262; "Rare Realist," *MD* (Sept. 1973), p. 40; Henry Adams, in *American Drawings and Watercolors in the Museum of Art, Carnegie Institute,* intro. by Henry Adams (Pittsburgh, 1985), pp. 170–71, 275–76.

EXHIBITIONS: Frank K. M. Rehn, Inc., New York, 1943, *Watercolors by Edward Hopper,* no. 3; Walker Art Center, Minneapolis, 1945, *American Watercolor and Winslow Homer* (trav. exh.), unnumbered; Pennsylvania Academy of the Fine Arts, Philadelphia, 1945, *The Forty-Third Annual Philadelphia Watercolor and Print Exhibition, and the Forty-Fourth Annual Exhibition of Miniatures,* no. 252; Art Institute of Chicago, 1946, *The Fifty-Seventh Annual American Exhibition: Water Colors and Drawings,* no. 32; Albertina, Vienna, 1949–50, *Amerikanische Meister des Aquarells* (trav. exh.), no. 32; Whitney Museum of American Art, New York, 1950, *Edward Hopper Retrospective Exhibition* (trav. exh.), no. 128; American Pavilion, Venice, 1952, *XXVI Biennale di Venezia,* no. 29; Department of Fine Arts, Carnegie Institute, Pittsburgh, 1957, *Drawings and Watercolors from the Collection of Mr. and Mrs. James H. Beal,* no catalogue; Whitney

Museum of American Art, New York, 1964, *Edward Hopper,* no. 131; William A. Farnsworth Library and Art Museum, Rockland, Me., 1971, *Edward Hopper 1882–1967: Oils, Watercolors, Etchings* (trav. exh.), no. 41; Andrew Crispo Gallery, New York, 1974, *Ten Americans: Masters of Watercolor,* no. 92; Museum of Art, Carnegie Institute, Pittsburgh, 1983, *Masterpieces of American Drawing and Watercolor,* no. 28; Museum of Art, Carnegie Institute, Pittsburgh, 1983–84, *American Watercolors and Drawings from the Collection of the Museum of Art, Carnegie Institute* (trav. exh.), no catalogue.

PROVENANCE: Frank K. M. Rehn, Inc., New York, until 1947; Mr. and Mrs. James H. Beal, Pittsburgh, 1947.

Gift of Mr. and Mrs. James H. Beal, 60.3.3

61. JOHN KANE
1860–1934

Bloomfield Bridge, c. 1930
(Pittsburgh Landscape; Skunk Hollow)

Oil on canvas
19 3/8 x 23 3/8 in. (49.2 x 59.4 cm)
Signature: John Kane (lower left)

REFERENCES: William Schack, "Around the Galleries," *Creative Art* 9 (Oct. 1931), p. 325; David L. Smith, "John Kane, Pittsburgh's Primitive," *American Artist* 33 (Apr. 1959), pp. 46–51, 87–88; Leon Anthony Arkus, *John Kane,*

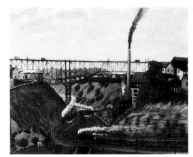
Bloomfield Bridge

Painter, Catalogue Raisonné (Pittsburgh, 1971), no. 123; Marianne Berardi, in *American Paintings and Sculpture to 1945 in The Carnegie Museum of Art,* by Diana Strazdes, et al. (New York, 1992), pp. 286–87.

EXHIBITIONS: Contemporary Arts Gallery, New York, 1931, *John Kane Exhibition,* no. 13, as *Skunk Hollow;* Cincinnati Art Museum, Ohio, 1935, *Forty-Second Annual Exhibition of American Art,* no. 85; Valentine Gallery, New York, 1935, *Memorial Exhibition of Selected Paintings by John Kane,* no. 27; Department of Fine Arts, Carnegie Institute, Pittsburgh, 1936, *John Kane Memorial Exhibition,* no. 31; M. Knoedler and Co., London, 1936, *Exhibition of Paintings by John Kane,* no. 4; Department of Fine Arts, Carnegie Institute, Pittsburgh, 1960, *Promised or Given,* no catalogue; Museum of Art, Carnegie Institute, Pittsburgh, 1966, *Three Self-Taught Pennsylvania Artists: Hicks, Kane, Pippin* (trav. exh.), no. 123; Galerie St. Etienne, New York, 1984, *John Kane: Modern America's First Folk Painter* (trav. exh.), no. 35; Galerie St. Etienne,

New York, 1988–89, *Folk Artists at Work,* no. 35.

PROVENANCE: The artist, until 1934; Valentine Gallery, New York; Maynard Walker Gallery, New York; Mr. and Mrs. James H. Beal, Pittsburgh, 1954.

Gift of Mr. and Mrs. James H. Beal, 81.54.2

Two Clowns with Dog

62. WALT KUHN
1877–1949

Two Clowns with Dog, 1940

Pen and ink on paper
8 $^1/_2$ x 10 $^5/_{16}$ in. (21.6 x 26.2 cm)

EXHIBITIONS: Cincinnati Art Museum, Ohio, 1960, *Walt Kuhn, A Memorial Exhibition,* no. 142; Maynard Walker Gallery, New York, 1962, *Exhibition of Drawings and Watercolors by Walt Kuhn,* no. 32; University of Arizona Museum of Art, Tucson, 1966, *Walt Kuhn, Painter of Vision,* no. 157.

PROVENANCE: Maynard Walker Gallery, New York; Mr. and Mrs. James H. Beal, Pittsburgh, 1962.

Bequest of Mr. and Mrs. James H. Beal, 93.189.40

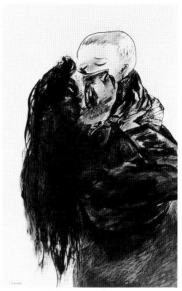
Mother and Child

63. YASUO KUNIYOSHI
1893–1953

Mother and Child, 1946–47

Pen and ink, brush and ink on card
21 $^1/_8$ x 14 $^3/_8$ in. (53.6 x 36.5 cm)
Signature: Kuniyoshi (lower left)

REFERENCE: *American Drawings and Watercolors in the Museum of Art, Carnegie Institute,* intro. by Henry Adams (Pittsburgh, 1985), p. 281.

EXHIBITION: Department of Fine Arts, Carnegie Institute, Pittsburgh, 1957, *Drawings and Watercolors from the Collection of Mr. and Mrs. James H. Beal,* no catalogue.

PROVENANCE: The Downtown Gallery, Inc., New York; Mr. and Mrs. James H. Beal, Pittsburgh, 1948.

Gift of Mr. and Mrs. James H. Beal, 51.27.29

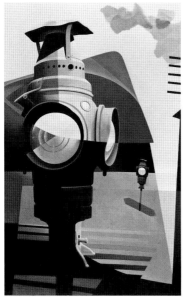

Lanterns

64. WILLIAM C. LIBBY
1870–1982

Lanterns, 1945

Tempera on board
26 ⁵/₈ x 17 ¹/₈ in. (67.6 x 43.5 cm)
Signature: WL (lower left)

REFERENCES: Sam Hood, "Pittsburgh's Artist of the Year," *Pittsburgh Press Roto,* Jan. 5, 1958, p. 46; Norman Kent, "William Charles Libby," *American Artist* 23 (Jan. 1959), p. 46; Elizabeth Morgan, in *American Paintings and Sculpture to 1945 in The Carnegie Museum of Art,* by Diana Strazdes, et al. (New York, 1992), pp. 325–26.

EXHIBITIONS: Arts and Crafts Center of Pittsburgh, 1958, *William Charles Libby: Pittsburgh's Artist of the Year,* no. 14; Carnegie Mellon University Art Gallery,

Pittsburgh, 1986, *William Charles Libby: A Retrospective,* no. 2.

PROVENANCE: Mr. and Mrs. James H. Beal, Pittsburgh, by 1958.

Gift of Mr. and Mrs. James H. Beal, 63.1.5

Bennington, Vermont

65. JOHN MARIN
1870–1953

Bennington, Vermont, c. 1924

Crayon on paper mounted on cardboard
7 ¹/₂ x 10 in. (19 x 25.4 cm)
Signature: Marin (lower right)
Inscription: Bennington, Vt (lower left)

PROVENANCE: An American Place, New York; Mr. and Mrs. James H. Beal, at the Women's Committee auction, Department of Fine Arts, Carnegie Institute, Pittsburgh,1962.

Bequest of Mr. and Mrs. James H. Beal, 93.189.42

66. JOHN MARIN
1870–1953

Sea Piece No. 21, Small Point, Maine, 1928

Charcoal and watercolor on paper
14 ¹/₄ x 17 ³/₄ in. (36.2 x 45 cm)

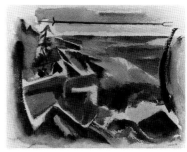

Sea Piece No. 21, Small Point, Maine

Signature, date: Marin 28 (lower right)

Color illustration 7.

REFERENCE: Sheldon Reich, *John Marin, Catalogue Raisonné, Part II* (Tucson, 1970), p. 599.

EXHIBITIONS: An American Place, New York, 1930, *John Marin,* no. 21; Museum of Modern Art, New York, 1936, *John Marin,* no. 112; Department of Fine Arts, Carnegie Institute, Pittsburgh, 1957, *Drawings and Watercolors from the Collection of Mr. and Mrs. James H. Beal,* no catalogue; Department of Fine Arts, Carnegie Institute, Pittsburgh, 1963, *Art Since 1900 — Privately Owned in the Pittsburgh Area,* no catalogue; Museum of Art, Carnegie Institute, Pittsburgh, 1971–72, *Forerunners of American Abstraction,* no. 62; The Art Museum, Princeton University, Princeton, N.J., 1972, *European and American Art from Princeton Alumni Collections,* no. 112.

PROVENANCE: Paul Rosenfeld, New York; The Downtown Gallery, Inc., New York; Mr. and Mrs. James H. Beal, Pittsburgh, 1947.

Bequest of Mr. and Mrs. James H. Beal, 93.189.41

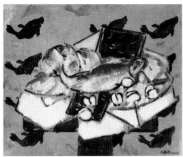
Still Life with Fish

67. ALFRED MAURER
 1868–1932

Still Life with Fish, c. 1927

Tempera on board
18 1/4 x 21 7/8 in. (46.3 x 55.5 cm)
Signature: A H Maurer (lower right)

EXHIBITION: Department of Fine
Arts, Carnegie Institute, Pittsburgh,
1957, *Drawings and Watercolors
from the Collection of Mr. and
Mrs. James H. Beal,* no catalogue.

PROVENANCE: Weyhe Gallery, New
York.

Bequest of Mr. and Mrs. James H.
Beal, 93.189.43

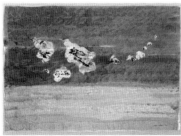
Autumn #3

68. CARL MORRIS
 1911–1993

Autumn #3, 1954

Watercolor on japan paper hinged
to grasscloth

17 1/8 x 24 1/2 in. (43.5 x 62.2 cm)
Signature, date: Carl Morris '54
(lower right)

EXHIBITIONS: Kraushaar
Galleries, New York, 1956, *Carl
Morris,* no catalogue; Department
of Fine Arts, Carnegie Institute,
Pittsburgh, 1957, *Drawings and
Watercolors from the Collection of
Mr. and Mrs. James H. Beal,* no
catalogue.

PROVENANCE: Kraushaar Galler-
ies, Inc., New York; Mr. and Mrs.
James H. Beal, Pittsburgh, 1956.

Bequest of Mr. and Mrs. James H.
Beal, 93.189.44

Across the Marshes

69. HENRY VARNUM POOR
 1887–1970

Across the Marshes, 1951

Watercolor and pastel on paper
15 1/4 x 17 in. (38.7 x 43.1 cm)
Signature: H V Poor (lower right)

EXHIBITIONS: Whitney Museum
of American Art, New York, 1953,
*Annual Exhibition of Contempo-
rary American Sculpture,
Watercolors and Drawings,*
no. 170; Department of Fine Arts,
Carnegie Institute, Pittsburgh,

1957, *Drawings and Watercolors
from the Collection of Mr. and
Mrs. James H. Beal,* no catalogue.

PROVENANCE: Frank K. M. Rehn,
Inc., New York.

Bequest of Mr. and Mrs. James H.
Beal, 93.189.47

Figs in a Bowl

70. HENRY VARNUM POOR
 1887–1970

Figs in a Bowl, c. 1952

Oil on board
11 3/4 x 15 3/4 in. (29.8 x 40 cm)
Signature: H V Poor (lower left)

EXHIBITIONS: Department of Fine
Arts, Carnegie Institute, Pittsburgh,
1952, *Pittsburgh International
Exhibition of Contemporary
Painting,* no. 217; California
Palace of the Legion of Honor,
San Francisco, 1953.

PROVENANCE: Frank K. M. Rehn,
Inc., New York

Bequest of Mr. and Mrs. James H.
Beal, 93.189.48

71. MAURICE BRAZIL
 PRENDERGAST
 1858–1924

The Picnic, 1901

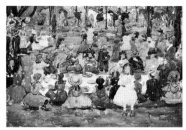

The Picnic

Graphite and watercolor on paper
15 5/16 x 22 1/8 in. (38.9 x 56.2 cm)
Signature: Prendergast (lower right)
Inscription: Picnic May Day Central Park (on reverse)

Color illustration 9.

REFERENCES: Jacob Getlar Smith, "The Watercolors of Maurice Prendergast," *American Artist* 20 (Feb. 1956), pp. 52–57; Herdis B. Teilman, "Recent Acquisitions: Museum of Art," *Carnegie Magazine* 46 (Oct. 1973), p. 343; "La Chronique des Arts," *Gazette des Beaux-Arts* 83 (Feb. 1974), supp., p. 145; Sophie Monneret, *Dictionnaire de l'Impressionisme et son Époque,* vol. 2 (Paris, 1979), p. 137; Henry Adams, in *American Drawings and Watercolors in the Museum of Art, Carnegie Institute,* intro. by Henry Adams (Pittsburgh, 1985), pp. 129–33; Carol Clark, Nancy Mowell Mathews, and Gwendolyn Owens, *Maurice Brazil Prendergast, Charles Prendergast. A Catalogue Raisonné* (Williamstown, Mass., and Munich, Germany, 1990), p. 414.

EXHIBITIONS: Harvard Society for Contemporary Art, Cambridge, Mass., 1929, *Maurice Prendergast 1861 [sic]–1924: A Memorial Exhibition,* no. 25; Department of Fine Arts, Carnegie Institute, Pittsburgh, 1957, *Drawings and Watercolors from the Collection of Mr. and Mrs. James H. Beal,* no catalogue; Museum of Art, Carnegie Institute, Pittsburgh, 1983, *Masterpieces of American Drawing and Watercolor,* no. 37; Museum of Art, Carnegie Institute, Pittsburgh, 1985, *American Drawings and Watercolors from the Collection of the Museum of Art, Carnegie Institute* (trav. exh.), no catalogue; The Carnegie Museum of Art, Pittsburgh, 1990, *The Changing Face of America: Selections from the Museum's Collection of American Drawings and Watercolors,* no catalogue; Milwaukee Art Museum, Wis., 1991, *Painters of a New Century: The Eight* (trav. exh.), no. 27.

PROVENANCE: Charles Prendergast, 1924; Mrs. Charles Prendergast, 1948; Kraushaar Galleries, Inc., New York; Mr. and Mrs. James H. Beal, Pittsburgh, 1949.

Gift of Mr. and Mrs. James H. Beal, 73.4

72. CHARLES SHEELER
1883–1965

Thundershower, 1948

Tempera on board
13 1/2 x 19 1/2 in. (34.3 x 49.5 cm)
Signature, date: Charles Sheeler 48 (lower right)

Color illustration 10.

EXHIBITIONS: The Downtown Gallery, Inc., New York, 1949,

Thundershower

Charles Sheeler, no. 18; National Collection of Fine Arts, Smithsonian Institution, Washington, D.C., 1968, *Charles Sheeler* (trav. exh.), no. 113; Museum of Art, Carnegie Institute, Pittsburgh, 1971–72, *Forerunners of American Abstraction,* no. 95.

PROVENANCE: The Downtown Gallery, Inc., New York, 1949.

Bequest of Mr. and Mrs. James H. Beal, 93.189.49

73. EUGENE SPEICHER
1883–1962

Nude, n.d.

Graphite, charcoal, and pastel on paper
14 7/8 x 9 in. (37.8 x 22.9 cm)
Signature: Eugene Speicher (lower right)

REFERENCE: *American Drawings and Watercolors in the Museum of Art, Carnegie Institute,* intro. by Henry Adams (Pittsburgh, 1985), p. 303.

EXHIBITION: Department of Fine Arts, Carnegie Institute, Pittsburgh, 1957, *Drawings and Watercolors from the Collection of Mr. and Mrs. James H. Beal,* no catalogue.

Nude

PROVENANCE: Frank K. M. Rehn, Inc., New York.

Gift of Mr. and Mrs. James H. Beal, 83.62.2

Portrait of Betty Schnabel

74. BENTON SPRUANCE
1904–1967

Portrait of Betty Schnabel, 1929

Lithograph
Ruth E. Fine and Robert F. Looney, *The Prints of Benton*

Murdoch Spruance, A Catalogue Raisonné (Philadelphia, 1986), no. 12 [hereafter Fine and Looney]. Edition size unknown.
9 ¹/₈ x 8 ¹/₈ in. (23.4 x 20.5 cm)
Signature: Benton Spruance (lower right)
Inscriptions: Portrait of Betty Schnabel (lower left), Print awarded Mary Smith Bridge (?) — Philadelphia Print Club — Autumn — 1929 — (bottom left)

Gift of Mrs. James H. Beal, 57.3.53

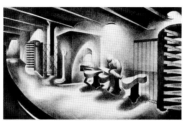

Bulldog Edition

75. BENTON SPRUANCE
1904–1967

Bulldog Edition, 1932

Lithograph
Fine and Looney 76. Edition of 30.
8 ⁷/₈ x 14 ¹/₂ in. (22.7 x 36.7 cm)
Signature: Benton Spruance (lower right)
Inscription: 25/30 Bulldog Edition (lower left)

Gift of Mrs. James H. Beal, 57.3.11

76. BENTON SPRUANCE
1904–1967

Shells for the Living, 1933

Lithograph
Fine and Looney 80. Edition of 28.
15 ⁷/₁₆ x 7 ⁷/₁₆ in. (39.2 x 18.8 cm)

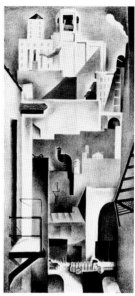

Shells for the Living

Signature: Benton Spruance (lower right)
Inscriptions: Shells of the Living (center); 25/28 (lower left); Shells of the Living (bottom left)

Gift of Mrs. James H. Beal, 57.3.59

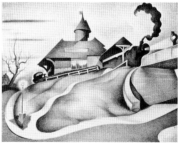

Late Departure

77. BENTON SPRUANCE
1904–1967

Late Departure, 1933

Lithograph
Fine and Looney 89. Edition of 30.
9 ³/₄ x 12 ¹/₂ in. (24.8 x 31.7 cm)
Signature: Benton Spruance (lower right)

Inscription: 5/30 Late Departure
(lower left)

Gift of Mrs. James H. Beal, 57.3.36

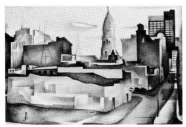

Changing City

78. BENTON SPRUANCE
 1904–1967

Changing City, 1934

Lithograph
Fine and Looney 93. Edition of 36.
9³/₁₆ x 14⁹/₁₆ in. (24.5 x 36.9 cm)
Signature: Benton Spruance
(lower right)
Inscription: 3/36 Changing City
(lower left)

Gift of Mrs. James H. Beal, 57.3.14

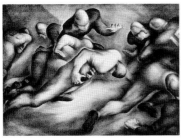

Spinner Play

79. BENTON SPRUANCE
 1904–1967

Spinner Play, 1934

Lithograph
Fine and Looney 105. Edition of 50.
13⁷/₈ x 19⁵/₁₆ in. (35.3 x 49 cm)
Signature: Benton Spruance
(lower right)

Inscription: Spinner Play (center);
26/50 (lower right)

Gift of Mrs. James H. Beal, 57.3.65

Traffic Control

80. BENTON SPRUANCE
 1904–1967

Traffic Control, 1936

Lithograph
Fine and Looney 132. Edition of 30.
8⁷/₈ x 14³/₈ in. (22.6 x 36.5 cm)
Signature: Benton Spruance (center)
Inscription: Traffic Control (center)

Gift of Mrs. James H. Beal, 57.3.68

81. BENTON SPRUANCE
 1904–1967

The Bridge from Race Street,
1939

Lithograph
Fine and Looney 165. Edition of 35.
15⁵/₁₆ x 8¹/₂ in. (39 x 21.5 cm)
Signature: Spruance (lower right)
Inscription: The Bridge from Race
Street (center); Ed 35 (lower left)

Gift of Mrs. James H. Beal, 57.3.10

82. BENTON SPRUANCE
 1904–1967

Pass to the Flat, 1939

Lithograph
Fine and Looney 167. Edition of 40.

The Bridge from Race Street

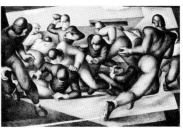

Pass to the Flat

13⁷/₈ x 20⁷/₈ in. (35.3 x 53.2 cm)
Signature: Spruance (lower right)
Inscription: — Pass to the Flat —
(center); Ed 40 (lower right)

Gift of Mrs. James H. Beal, 57.3.46

83. BENTON SPRUANCE
 1904–1967

The People at Play — Spring,
1939

Lithograph
Fine and Looney 170. Edition of 40.
14 x 17⁷/₈ in. (35.7 x 45.4 cm)
Signature: Spruance (lower right)
Inscription: The People Play

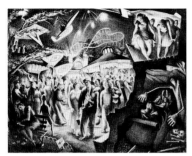

The People at Play — Spring

Girl with Hands to Face

Spring (center); Ed 30 (lower left)

Gift of Mrs. James H. Beal, 57.3.47

84. BENTON SPRUANCE
1904–1967

Girl with Hands to Face, 1940

Lithograph
Fine and Looney 180. Edition of 30.
15 $^{15}/_{16}$ x 10 $^{1}/_{16}$ in. (40.4 x 25.5 cm)
Signature: Spruance (lower right)
Inscription: Girl with Hands to
Face (center); Ed 30 (lower left)

Gift of Mrs. James H. Beal, 57.3.28

American Pattern — Barn

85. BENTON SPRUANCE
1904–1967

American Pattern — Barn, 1940

Lithograph
Fine and Looney 184. Edition of 45.
7 $^{5}/_{8}$ x 14 in. (19.4 x 35.5 cm)
Signature: Spruance (lower right)
Inscription: American Pattern —
Barn (center); Ed 45 — (lower left)

Gift of Mrs. James H. Beal, 57.3.2

Arrangement for Drums

86. BENTON SPRUANCE
1904–1967

Arrangement for Drums, 1941

Lithograph
Fine and Looney 191. Edition of 30.
9 $^{3}/_{8}$ x 14 $^{5}/_{8}$ in. (23.9 x 37.3 cm)
Signature: Benton Spruance
(lower right)
Inscription: Arrangement for
Drums (center); Ed 30 (lower left)

Gift of Mrs. James H. Beal, 57.3.5

The Artist as Model

87. BENTON SPRUANCE
1904–1967

The Artist as Model, 1942

Lithograph
Fine and Looney 204. Edition of 30.
11 $^{3}/_{8}$ x 14 $^{9}/_{16}$ in. (28.8 x 37 cm)
Signature: Spruance (lower right)
Inscription: — The Artist as
Model — (center); Ed 30 (lower left)

Gift of Mrs. James H. Beal, 57.3.6

Riders of The Apocalypse

88. BENTON SPRUANCE
1904–1967

Riders of The Apocalypse, 1943

Lithograph
Fine and Looney 222. Edition of 35.
12 $^{11}/_{16}$ x 16 $^{3}/_{8}$ in. (32.2 x 41.6 cm)
Signature, date: Spruance 43
(lower right)
Inscription: Riders of The Apoca-
lypse (center); Ed 30 (lower left)

Gift of Mrs. James H. Beal, 57.3.55

Bacchanale

89. MARK TOBEY
1890–1976

Bacchanale, 1957

Tempera on board
10 ⅛ x 12 in. (25.7 x 30.5 cm)
Signature, date: Tobey 57 (lower right)

EXHIBITIONS: Museum of Art, Ogunquit, Me., 1958, *6th Annual Exhibition,* no catalogue; Department of Fine Arts, Carnegie Institute, Pittsburgh, 1963, *Art Since 1900 — Privately Owned in the Pittsburgh Area,* no catalogue.

PROVENANCE: Willard Gallery, New York.

Bequest of Mr. and Mrs. James H. Beal, 93.189.51

90. JOHN WILDE
b. 1919

Self-Portrait with Milkweed, 1954

Graphite heightened with white on blue paper
22 ⅝ x 16 in. (57.4 x 40.6 cm)
Inscription: Myself at 34 years with an incidental rendering of the common Marsh milkweed dessicated Jonathan E.W. Jan. 1954.

Self-Portrait with Milkweed

EXHIBITION: Department of Fine Arts, Carnegie Institute, Pittsburgh, 1957, *Drawings and Watercolors from the Collection of Mr. and Mrs. James H. Beal,* no catalogue.

PROVENANCE: Edwin P. Hewitt Gallery, New York; Mr. and Mrs. James H. Beal, Pittsburgh, 1954.

Bequest of Mr. and Mrs. James H. Beal, 93.189.52

91. ANDREW WYETH
b. 1917

September Sea, c. 1953

Watercolor on paper mounted on board
21 ⅝ x 24 ⅜ in. (54.9 x 61.9 cm)
Signature: Andrew Wyeth (lower right)

Color illustration 15.

EXHIBITIONS: Whitney Museum of American Art, New York, 1953,

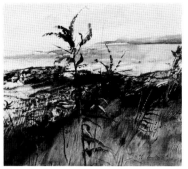
September Sea

Annual Exhibition of Contemporary American Sculpture, Watercolors and Drawings, no. 139; Museum of Art, Carnegie Institute, Pittsburgh, 1957, *Drawings and Watercolors from the Collection of Mr. and Mrs. James H. Beal,* no catalogue; Department of Fine Arts, Carnegie Institute, Pittsburgh, 1963, *Art Since 1900 — Privately Owned in the Pittsburgh Area,* no catalogue.

PROVENANCE: William Macbeth Gallery, Inc., New York; Mr. and Mrs. James H. Beal, Pittsburgh, 1953.

Bequest of Mr. and Mrs. James H. Beal, 93.189.53

ROGER ANLIKER
b. 1924

Fireworks at La Coruña, 1956–57
Gouache on paper
21 1/2 x 29 3/4 in. (54.6 x 75.4 cm)
Signature, date: Anliker 1956–57
(lower right)

Gift of Mr. and Mrs. James H. Beal,
60.3.1

WILL BARNET
b. 1911

Big Duluth, 1959
Monotype
31 1/8 x 18 7/8 in. (79 x 48 cm)
Signature: Will Barnet (lower
right)

Gift of Mr. and Mrs. James H. Beal,
63.1.1

Big Duluth I, 1958
Ballpoint pen and gouache on paper,
mounted on paper
8 1/2 x 4 15/16 in. (21.6 x 12.4 cm)
Signature, date: Barnet '58 (lower
right)

Gift of Mr. and Mrs. James H. Beal,
63.1.2

Great Lake, 1958
Graphite, pen and ink, and gouache
on paper, mounted on paper

8 7/16 x 5 3/8 in. (21.4 x 13.6 cm)
Signature: Will Barnet (lower
center)

Gift of Mr. and Mrs. James H. Beal,
63.1.3

LEONARD BASKIN
b. 1922

Head, c. 1965
Graphite, brush, and ink on paper
18 1/8 x 22 5/8 in. (46 x 57.4 cm)

Gift of Mr. and Mrs. James H. Beal,
67.3.1

JULIUS BISSIER
1893–1965

A. 26. Nov. 63, 1963
Tempera and oil on canvas
7 1/4 x 9 7/8 in. (18.4 x 25 cm)
Signature: Julius Bissier (lower
left)

Gift of Mr. and Mrs. James H. Beal,
65.3.1

22. Dec. 63, 1963
Tempera and oil on canvas
8 x 9 7/8 in. (20.3 x 25 cm)
Signature: Julius Bissier (lower
right)

Gift of Mr. and Mrs. James H. Beal,
65.3.2

EDMUND BLAMPIED
1886–1966

Loading Seaweed, 1924
Etching
7 x 10 1/8 in. (17.8 x 25.7 cm)
Signature: E Blampied (lower right);
69/100 (lower left)

Gift of Mr. and Mrs. James H. Beal,
58.31

DAVID GILMOUR BLYTHE
1815–1865

Man Eating in a Field, c. 1856–63
Oil on canvas
10 x 14 1/8 in. (25.4 x 35.9 cm)
Signature: Blythe (lower left)

Museum purchase: gift of Mr. and
Mrs. James H. Beal, 54.31.3

Confederate Soldier at the Well,
c. 1861
Oil on canvas
11 7/8 x 18 in. (30.1 x 45.7 cm)
Signature: Blythe (lower left)

Museum purchase: gift of Mr. and
Mrs. James H. Beal, 54.31.1

Harvesting, c. 1863–64
Oil on canvas
10 x 14 in. (25.4 x 35.6 cm)
Signature: Blythe (lower right)

Museum purchase: gift of Mr. and Mrs. James H. Beal, 54.31.2

REG BUTLER
b. 1913

Figure in a Boat, 1957
Graphite on paper
9 x 11 1/2 in. (22.7 x 29.9 cm)
Signature, date: Butler '57 (lower left)

Gift of Mr. and Mrs. James H. Beal, 63.1.4

VIRGIL CANTINI
b. 1919

Reconstruction, 1965
Relief print
12 1/4 x 19 in. (31.1 x 48.2 cm)
Signature, date: Cantini '65 (lower right)

Gift of Mr. and Mrs. James H. Beal, 67.14

WILLIAM CROZIER
b. 1933

Essex Wilderness, 1960
Oil on Masonite
60 x 48 in. (152.4 x 122 cm)
Signature: Crozier (lower right)

Patrons Art Fund: gift of Mrs. James H. Beal, 61.30

ADOLPH DIODA
b. 1915

St. Francis and the Wolf, 1951
Sandstone
30 x 10 3/4 x 9 in. (76.2 x 27.3 x 22.8 cm)

Gift of Mr. and Mrs. James H. Beal, 55.36.4

LEONARD EDMONDSON
b. 1916

Cabal, n.d.
Etching
15 5/8 x 19 in. (39.7 x 48.2 cm)
Signature: Edmondson (lower right); 6/50 (lower left)

Gift of Mr. and Mrs. James H. Beal, 67.3.8

JOHN B. FLANNAGAN
1895–1942

Horse, c. 1932–35
Granite
6 1/2 x 3 1/2 x 12 in. (16.5 x 8.9 x 30.4 cm)

Bequest of Mr. and Mrs. James H. Beal, 93.189.31

ANTONIO FRASCONI
b. 1919

Sea and Rain, 1955
Woodcut
19 1/4 x 34 1/8 in. (48.9 x 86.7 cm)
Signature, date, inscription: Frasconi '55 (lower right); Sea and Rain (lower left)

Gift of Mr. and Mrs. James H. Beal, 65.1.1

ROBERT E. GARDNER
b. 1919

Winter Image, 1966
Lithograph
17 x 22 in. (43.1 x 55.9 cm)
Signature, date, inscription: Robert Gardner 1966 (lower right); Trial proof (lower center); Winter Image (lower left)

Gift of Mr. and Mrs. James H. Beal, 67.3.9

BALCOMB GREENE
1904–1990

Abstraction, 1952
Oil on canvas
34 1/8 x 44 7/8 in. (86.7 x 114 cm)
Signature: Balcomb Greene (lower right)

Gift of Mr. and Mrs. James H. Beal, 55.1

ROBERT INDIANA
b. 1928

Love, 1966
Polished aluminum
12 x 12 x 6 in. (30.5 x 30.5 x 15.2 cm)
Signature, date, markings: Indiana 5/6 — '67 (bottom); HF (foundry mark, carved by Herbert Feuerlight, bottom)

Gift of Mr. and Mrs. James H. Beal, 71.47.1

Love, 1967
Serigraph
33 3/4 x 33 3/4 in. (85.7 x 85.7 cm)
Signature: R. Indiana (on reverse); 72/100 (on reverse)

Gift of Mr. and Mrs. James H. Beal, 71.47.2

(attributed to)
ANGELICA KAUFFMANN
1741–1807

Head of a Woman, n.d.
Ink and wash on paper
6 9/16 x 5 in. (16.6 x 12.7 cm)

Gift of Mr. and Mrs. James H. Beal, 67.3.10

WILLIAM KIENBUSCH
1914–1980

New England Stove, 1948
Casein with newspaper collage
39 1/2 x 26 1/2 in. (100.3 x 67.3 cm)
Signature, date: Kienbusch 48
(lower right)

Gift of Mr. and Mrs. James H. Beal,
58.1

Coast, Hurricane Island, 1955
Casein on paper
27 x 40 1/2 in. (68.5 x 102.9 cm)
Signature, date: Kienbusch 55
(lower right)

Gift of Mr. and Mrs. James H. Beal,
56.49

DONG KINGMAN
b. 1911

House in Brooklyn, n.d.
Brush and ink on paper
20 3/4 x 14 7/8 in. (52.7 x 37.8 cm)
Signature: Kingman (lower right)

Gift of the Estate of Mr. and Mrs.
James H. Beal, 93.189.39

WILLIAM CHARLES LIBBY
1919–1982

Lanterns, c. 1940
Lithograph
13 1/8 x 10 3/8 in. (33.3 x 26.3 cm)
Signature, inscription: William
Charles Libby (lower right); Lanterns
5/25 (lower left)

Gift of Mr. and Mrs. James H. Beal,
58.31.3

Holiday, c. 1940
Lithograph
10 x 12 1/4 in. (25.4 x 31.1 cm)
Signature, inscription: William

Charles Libby (lower right); Holiday
2/25 (lower left)

Gift of Mr. and Mrs. James H. Beal,
58.31.2

JAMES MCBEY
1883–1959

Advance on Jerusalem, 1920
Drypoint
8 x 14 in. (20.3 x 35.6 cm)
Signature: James McBey (lower
right)

Gift of Mr. and Mrs. James H. Beal,
58.31.4

RINALDO PALUZZI
b. 1927

Untitled, 1962
Charcoal, ink, and pencil on paper
25 x 18 7/8 in. (63.5 x 48 cm)

Gift of Mr. and Mrs. James H. Beal,
67.3.11

FAUSTO PIRANDELLO
1899–1975

Nude, 1952
Oil on board
27 5/8 x 39 1/4 in. (70.1 x 99.7 cm)
Signature: Pirandello (lower left)

Gift of Mr. and Mrs. James H. Beal,
52.18

HENRY VARNUM POOR
1888–1971

Pitcher, 1953
glazed earthenware
6 3/4 x 4 1/2 in. (17.2 x 11.4 cm)
Signature, date: H V P 53 (incised on
bottom)

Bequest of Mr. and Mrs. James H.
Beal, 93.189.46

GEORGES ROUAULT
1871–1958

Le Christ en Croix, 1929
Lithograph
12 11/16 x 9 1/2 in. (32.1 x 24.1 cm)
Signature, date: 1929 — G. Rouault
(lower right)

Gift of Mr. and Mrs. James H. Beal,
67.3.12

MILLARD SHEETS
1907–1989

The Camel Woman, 1944
From the series *India Village*
Graphite, charcoal, and watercolor on
paper mounted on Masonite
39 1/8 x 24 in. (99.4 x 61 cm)
Signature: Millard Sheets (lower
right)

Gift of Mr. and Mrs. James H. Beal,
49.1

GUSTAVE SINGIER
1909–1984

L'Enchanteur, 1954
Oil on canvas
57 1/2 x 45 in. (146 x 114.3 cm)
Signature, date: G. Singier/54 (lower
left)

Gift of Mr. and Mrs. James H. Beal,
77.1

BENTON SPRUANCE
1904–1967

LITHOGRAPHS

Each lithograph is signed in pencil by
the artist.

The following are the gifts of
Mrs. James H. Beal:

Old Wall of Florence, 1928
Ruth E. Fine and Robert F.

Looney, *The Prints of Benton Murdoch Spruance, A Catalogue Raisonné* (Philadelphia, 1986), no. 1 [hereafter Fine and Looney].
11 3/4 x 9 1/4 in. (29.8 x 23.5 cm)
57.3.44

House at Eaux Bonnes, 1930
Fine and Looney 41
13 3/4 x 11 5/16 in. (34.7 x 28.8 cm)
51.27.4

April—Wet, 1931
Fine and Looney 44
12 1/2 x 8 1/2 in. (31.7 x 21.7 cm)
57.3.4

Horses and Approaching Storm,
c. 1931
Fine and Looney 51
15 1/4 x 11 3/8 in. (39 x 29 cm)
57.3.33

Garden of Eden, 1932
Fine and Looney 64
9 5/8 x 12 3/8 in. (24.5 x 31.6 cm)
57.3.27

Approach to the Station, 1932
Fine and Looney 70
11 x 13 7/8 in. (28 x 35.5 cm)
57.3.3

City in the Rain, 1932
Fine and Looney 77
11 3/8 x 8 3/4 in. (28.8 x 22.5 cm)
51.27.9

Cat and Busybody, 1933
Fine and Looney 85
10 3/4 x 13 5/16 in. (27.4 x 33.5 cm)
57.3.12

Middle Germantown, 1934
Fine and Looney 98
10 x 13 3/4 in. (25.3 x 34.9 cm)
57.3.41

Schuylkill Bridges, 1934
Fine and Looney 100
9 1/16 x 14 5/8 in. (23 x 37.1 cm)
57.3.58

End Sweep, 1934
Fine and Looney 101
6 7/8 x 14 3/8 in. (17.4 x 36.5 cm)
57.3.20

Harps Once Played, 1935
Fine and Looney 112
10 3/4 x 13 7/8 in. (27.3 x 35.1 cm)
57.3.31

Philatelists, 1935
Fine and Looney 113
9 7/8 x 14 3/8 in. (25.1 x 36.5 cm)
57.3.50

Road from the Shore, 1936
Fine and Looney 130
10 1/8 x 14 3/8 in. (25.6 x 36.5 cm)
57.3.57

The People Work—Noon, 1937
Fine and Looney 142
13 7/8 x 19 7/8 in. (35 x 47.9 cm)
57.3.49

Macbeth—Act V, 1938
Fine and Looney 148
9 11/16 x 14 3/4 in. (24.6 x 37.4 cm)
57.3.39

Plans for the Future, 1939
Fine and Looney 162
9 7/8 x 14 3/8 in. (25 x 36.5 cm)
57.3.51

Girl with Pigtails, 1939
Fine and Looney 166
16 3/8 x 8 3/4 in. (41.6 x 22 cm)
57.3.30

Portrait at Dusk, 1939
Fine and Looney 174

15 3/4 x 10 1/8 in. (39.9 x 25.7 cm)
57.3.52

The 30s—Windshield, 1939
Fine and Looney 176
9 x 14 1/4 in. (22.7 x 36.2 cm)
57.3.66

Young Lincoln, 1940
Fine and Looney 183
18 1/4 x 11 7/16 in. (46.3 x 29 cm)
57.3.76

Gifts from the Kings, 1941
Fine and Looney 185
10 1/2 x 15 7/8 in. (26.7 x 40.4 cm)
57.3.21

Brief Balance, 1941
Fine and Looney 189
14 1/2 x 11 9/16 in. (36.6 x 29.4 cm)
57.3.8

Opening Note, 1941
Fine and Looney 192
12 7/8 x 8 1/8 in. (32.5 x 20.5 cm)
57.3.45

The Lamentation, 1941
Fine and Looney 199
12 3/8 x 18 5/16 in. (31.3 x 46 cm)
57.3.35

Last Stop—Beach Haven, 1941
Fine and Looney 201
9 x 15 3/16 in. (23 x 38.4 cm)
51.27.7

Farewell in the Dawn, 1942
Fine and Looney 205
14 7/8 x 10 1/8 in. (37.7 x 25.6 cm)
57.3.24

Souvenir of Lidice, 1943
Fine and Looney 216
12 1/8 x 18 3/8 in. (30.8 x 46.6 cm)
57.3.63

Fathers and Sons, 1943
Fine and Looney 226
11 $^1/_8$ x 20 $^3/_{16}$ in. (28.4 x 51.3 cm)
57.3.25

The People Play—Summer, 1944
Fine and Looney 228
13 x 19 $^{11}/_{16}$ in. (33 x 50 cm)
57.3.48

Portrait—Miss M. H., 1944
Fine and Looney 229
17 $^5/_{16}$ x 12 $^3/_8$ in. (43.9 x 31.4 cm)
51.27.8

End of Waiting, 1944
Fine and Looney 230
14 $^1/_4$ x 12 $^1/_6$ in. (36.1 x 30.6 cm)
57.3.19

Forward Pass, 1944
Fine and Looney 231
20 $^1/_{16}$ x 12 $^1/_2$ in. (51 x 31.6 cm)
57.3.26

Ridge Valley Churches, 1944
Fine and Looney 234
12 $^1/_2$ x 18 $^1/_2$ in. (31.7 x 47 cm)
57.3.56

Tulpehocken Road, 1944
Fine and Looney 235
12 x 16 in. (30.5 x 40.6 cm)
57.3.69

Sonia and Her Cello, 1944
Fine and Looney 236
19 x 13 $^1/_2$ in. (50.3 x 34.3 cm)
57.3.62

Dead Little Bird, 1945
Fine and Looney 237
7 $^7/_8$ x 12 $^1/_4$ in. (20 x 31.2 cm)
57.3.37

Kim and Art, 1945
Fine and Looney 238

14 $^3/_8$ x 18 in. (37 x 45.6 cm)
51.27.6

*A Wind is Rising and the Rivers
Flow,* 1945
Fine and Looney 242
14 $^1/_2$ x 19 $^3/_8$ in. (36.8 x 48.7 cm)
57.3.74

Ecclesiastes: Essay IV, 1946
Fine and Looney 248
17 $^5/_8$ x 12 $^3/_4$ in. (44.8 x 32.3 cm)
57.3.18

Dream of Love, 1947
Fine and Looney 252
12 $^7/_{16}$ x 17 in. (31.6 x 43.5 cm)
57.3.17

Night in Eden, 1947
Fine and Looney 254
16 $^1/_8$ x 12 $^1/_4$ in. (41 x 31.2 cm)
57.3.42

Behold the Man, 1947
Fine and Looney 258
14 $^1/_8$ x 10 $^1/_{16}$ in. (35.9 x 25.5 cm)
57.3.9

Eyes for the Night, 1948
Fine and Looney 261
19 x 12 $^7/_8$ in. (48.2 x 32.6 cm)
57.3.23

No Home for a Bird, 1948
Fine and Looney 264
12 $^7/_8$ x 17 $^1/_2$ in. (32.5 x 44.4 cm)
57.3.43

Asylum, 1948
Fine and Looney 265
15 $^1/_2$ x 13 $^1/_8$ in. (39.2 x 33.3 cm)
57.3.7

World of One's Own, 1948
Fine and Looney 266
13 $^5/_8$ x 17 $^5/_8$ in. (34.5 x 44.7 cm)
57.3.75

Adolescent—Mary Sturgeon, 1948
Fine and Looney 267
17 $^3/_4$ x 12 $^7/_8$ in. (45 x 32.7 cm)
57.3.1

Lot's Wife, 1948
Fine and Looney 268
19 $^1/_4$ x 14 $^1/_{16}$ in. (48.3 x 35.1 cm)
57.3.38

Jeanne in a Seminole Blouse, 1948
Fine and Looney 269
19 x 14 $^3/_4$ in. (48 x 37.5 cm)
57.3.34

Havoc in Heaven, 1948
Fine and Looney 270
18 $^{11}/_{16}$ x 13 in. (47.5 x 32.9 cm)
57.3.32

Somnambulist, 1948
Fine and Looney 271
12 $^5/_{16}$ x 19 $^1/_2$ in. (31.2 x 49 cm)
57.3.61

Memorial—To a Dead Child, 1949
Fine and Looney 273
19 $^5/_8$ x 14 in. (49.9 x 35.6 cm)
57.3.40

Soliloquy: Vanity of Decision, 1949
From the series *Vanity I: Vanity of
the Mind*
Fine and Looney 274
18 $^5/_8$ x 13 in. (47.4 x 33.2 cm)
57.3.60

Soliloquy: Vanity of Decision, 1949
From the series *Vanity I: Vanity of
the Mind*
Fine and Looney 275
18 $^{13}/_{16}$ x 13 in. (47.8 x 33 cm)
51.27.17

*Fallen Angel: Vanity of Disagree-
ment,* 1949
From the series *Vanity I: Vanity of
the Mind*

Fine and Looney 276
18 ⁵/₈ x 13 ¹/₈ in. (47.4 x 33.1 cm)
51.27.13

Of Course He Will Come: Vanity of Hope, 1949
From the series *Vanity I: Vanity of the Mind*
Fine and Looney 277
18 ⁷/₈ x 13 ¹/₄ in. (47.9 x 33.6 cm)
51.27.15

Set Pieces: Vanity of Trust, 1949
From the series *Vanity I: Vanity of the Mind*
Fine and Looney 279
13 x 18 ⁹/₁₆ in. (33 x 47.1 cm)
51.27.16

I'll Be What I Choose: Vanity of Ambition, 1949
From the series *Vanity I: Vanity of the Mind*
Fine and Looney 281
19 ¹³/₁₆ x 13 ¹/₄ in. (47.8 x 33.9 cm)
51.27.14

Saint Anthony, 1949
Fine and Looney 282
14 ¹/₈ x 10 ⁹/₁₆ in. (36 x 26.8 cm)
51.27.10

Vanities II: Memorial, 1950
Fine and Looney 283
18 ⁹/₁₆ x 13 ⁵/₈ in. (47.3 x 34.5 cm)
51.27.21

Broken Carousel, 1950
Fine and Looney 285
18 ¹/₂ x 13 ³/₈ in. (47 x 33.9 cm)
51.27.1

Vanities II: Lamentation, 1950
Fine and Looney 286
13 ³/₈ x 18 ¹/₂ in. (33.9 x 47 cm)
51.27.20

Variation, 1950
Fine and Looney 287
13 ⁵/₁₆ x 18 ¹/₂ in. (33.5 x 46.8 cm)
51.27.12

Vanities II: Judith, 1950
Fine and Looney 288
18 ¹/₂ x 13 ³/₈ in. (47.1 x 34 cm)
51.27.19

Vanities II: Jacob and the Angel, 1950
Fine and Looney 289
14 x 18 ³/₈ in. (35.4 x 46.7 cm)
51.27.18

Girl with Mask, 1950
Fine and Looney 290
20 ⁵/₈ x 12 ¹/₈ in. (52.3 x 30.9 cm)
51.27.2

Girl with Mask, 1950
Fine and Looney 291
20 ⁵/₈ x 12 ¹/₈ in. (52.3 x 30.9 cm)
51.27.3

Vanities II: Salome — and John, 1950
Fine and Looney 292
18 ¹/₄ x 13 ³/₈ in. (46.5 x 34 cm)
51.27.22

Subway Playground, 1951
Fine and Looney 295
19 x 13 ³/₄ in. (48.2 x 34.7 cm)
51.27.11

"Curse God — and Die," 1951
Fine and Looney 297
18 ⁵/₁₆ x 11 ¹/₂ in. (46.2 x 29.1 cm)
51.27.23

"My Hand I Lay upon My Mouth" — Job, 1951
Fine and Looney 298
18 ¹/₄ x 11 ¹/₂ in. (46.2 x 29.2 cm)
51.27.25

"When I Laid the Earth's Foundation" — Job, 1951
Fine and Looney 299
18 ¹/₄ x 11 ³/₄ in. (46.4 x 29.2 cm)
57.3.73

"Hast Thou Observed My Servant Job?," 1951
Fine and Looney 300
18 ³/₄ x 12 in. (47.4 x 30.2 cm)
51.27.24

"With You, Wisdom Will Die" — Job, 1951
Fine and Looney 301
18 ¹/₈ x 11 ¹¹/₁₆ in. (46 x 29.7 cm)
51.27.27

When I Laid the Earth's Foundation, 1951
Fine and Looney 303
18 ¹/₄ x 11 ³/₄ in. (46.4 x 29.2 cm)
51.27.26

Eternal Jacob, 1952
Fine and Looney 308
14 x 18 ⁷/₈ in. (35 x 47.3 cm)
57.3.22

The Long Night: Citizen, 1952
Fine and Looney 313
18 ⁷/₁₆ x 24 in. (46.8 x 61 cm)
57.3.15

The Long Night: Space Mask, 1952
Fine and Looney 314
19 ³/₁₆ x 13 ³/₈ in. (48.5 x 34 cm)
57.3.64

Prometheus, 1953
Fine and Looney 315
18 ¹/₄ x 14 ³/₄ in. (46.3 x 37.5 cm)
57.3.54

Death of the Minotaur, 1953
Fine and Looney 323

18 x 13 ⅝ in. (45.9 x 34.5 cm)
57.3.16

Centaur III—Apotheosis, 1954
Fine and Looney 340
21 ⁷/₁₆ x 16 ½ in. (54 x 41.9 cm)
57.3.13

Thornbush, 1955
Fine and Looney 355
23 ⅛ x 16 ⅝ in. (58.7 x 42 cm)
57.3.67

Water Jar, 1955
Fine and Looney 356
23 ⅛ x 16 ¾ in. (58.6 x 42.5 cm)
57.3.72

The following are the gifts of
Mr. and Mrs. James H. Beal:

*Anabasis 1: My Glory Is Upon The
Seas, My Strength Is Amongst You,*
1957
Fine and Looney 381
14 ⁷/₁₆ x 20 ⅞ in. (36.5 x 53 cm)
60.3.4.1

*Anabasis 2: I Tread, You Tread, In a
Land of High Slopes, Clothed in
Balm,* 1957
Fine and Looney 382
20 ¾ x 13 ¾ in. (52.5 x 34.9 cm)
60.3.4.2

*Anabasis 3: On the Point of a Lance,
Amongst Us, This Horse's Skull,*
1957
Fine and Looney 383
14 ¾ x 20 ¹³/₁₆ in. (36.7 x 52.8 cm)
60.3.4.3

*Anabasis 4: A Child—Offered Us a
Quail in a Slipper of Rose Coloured
Satin,* 1957
Fine and Looney 384
20 ⅝ x 14 ⅛ in. (52.3 x 35.7 cm)
60.3.4.4

*Anabasis 5: And the Stranger
Acquires Still More Partisans in the
Way of Silence,* 1957
Fine and Looney 385
14 ½ x 20 ⅞ in. (36.8 x 53 cm)
60.3.4.5

*Anabasis 6: Great Chargers of Gold
Held Up by the Handmaidens Smote
the Weariness of the Sands,* 1957
Fine and Looney 386
14 ¼ x 20 ⅜ in. (36 x 51.7 cm)
60.3.4.6

*Anabasis 7: The Shadow of a Great
Bird Falls on My Face,* 1957
Fine and Looney 387
20 ⅝ x 14 ⅛ in. (52.5 x 35.8 cm)
60.3.4.7

*Anabasis 8: Roads of the Earth We
Follow You. Authority over All the
Signs of the Earth,* 1957
Fine and Looney 388
14 ⅜ x 20 ⅞ in. (36 x 53 cm)
60.3.4.8

*Anabasis 9: I Foretell You the Time
of Great Blessing and the Bounty of
the Evening,* 1957
Fine and Looney 389
20 ¾ x 14 ¼ in. (52.7 x 36 cm)
60.3.4.9

*Anabasis 10: Plough-land of
Dream! Who Talks of Building?,*
1957
Fine and Looney 390
14 ½ x 20 ⅜ in. (36.7 x 51.8 cm)
60.3.4.10

Mourning Figure, 1959
Fine and Looney 406
22 ⅜ x 16 ½ in. (57.5 x 42.5 cm)
60.17.1

Return of the Goddess, 1959
Fine and Looney 412

18 ⁷/₁₆ x 24 ⅞ in. (46.9 x 63.2 cm)
60.17.2

Skyscape—Homage to Hodgson,
1964
Fine and Looney 470
20 ½ x 29 in. (52 x 74 cm)
65.1.2

Priapus, 1964
Fine and Looney 474
17 ⅝ x 23 ⅜ in. (44.7 x 59.2 cm)
77.56.5

Saint John, Eagle, 1964
Fine and Looney 478
26 ¾ x 18 ³/₁₆ in. (68 x 46.4 cm)
65.22

Saint Luke—Bull, 1965
Fine and Looney 480
19 x 24 in. (48.5 x 61.5 cm)
77.56.4

Studio Press, 1965
Fine and Looney 486
24 ⅜ x 17 in. (61.7 x 43.4 cm)
77.56.3

The Vise, 1966
Fine and Looney 502
25 ⅜ x 16 ½ in. (64.3 x 42.4 cm)
77.56.1

Moby Dick I: Call me Ishmael, 1967
Fine and Looney 528
28 ½ x 19 ¾ in. (72.5 x 50.5 cm)
77.56.2

BENTON SPRUANCE
1904–1967

WOODCUTS

The following are the gifts of
Mrs. James H. Beal:

Head of a Drum Majorette, 1951
Fine and Looney 551

14$^1/_8$ x 11$^1/_2$ in. (35.7 x 29.4 cm)
57.3.77

Jehovah and Satan, 1951
Fine and Looney 549b
18 x 10$^1/_8$ in. (45.9 x 25.5 cm)
51.27.5

The Word and Job, 1951
Fine and Looney 550
18$^1/_4$ x 11$^5/_8$ in. (46 x 29.2 cm)
57.3.78

DRAWINGS

The following are the gifts of
Mr. and Mrs. James H. Beal:

Tulpehocken Road, c. 1944
Casein on paper
20 x 28 in. (50.8 x 71.1 cm)
59.1.3

*A Child — Offered Us a Quail in a
Slipper of Rose Coloured Satin,*
c. 1957
Drawing for 4th lithograph in
Anabasis series
Graphite on paper
21 x 14$^1/_2$ in. (53.3 x 36.8 cm)
Signature: Spruance (lower right)
60.3.5.1

*Roads of the Earth, We Follow You.
Authority over All the Signs of the
Earth,* c. 1957
Drawing for 8th lithograph in
Anabasis series
Graphite on paper
14$^1/_2$ x 21$^3/_8$ in. (36.8 x 54.3 cm)
Signature: BS (lower right)
60.3.5.2

Lonely Carnival, c. 1958
Casein on paper
24$^7/_8$ x 16$^7/_8$ in. (63.2 x 42.8 cm)
Signature: BS (lower right)
59.1.2

Remainders, 1958
Graphite and gouache on paper
25$^{13}/_{16}$ x 19$^{13}/_{16}$ in. (65.5 x 50.2 cm)
Signature: BS (center right)
67.3.13

Web of Dream, 1960
Charcoal and chalk on paper
24 x 19 in. (61 x 48.3 cm)
Signature: BS (lower right)
67.3.14

GRAHAM SUTHERLAND
1903–1980

Maize, 1950
Lithograph
15$^1/_4$ x 21$^{15}/_{16}$ in. (38.7 x 55.6 cm)
Signature: Graham Sutherland
(lower left and right)

Gift of Mr. and Mrs. James H. Beal,
51.27.30

HENRI DE TOULOUSE-LAUTREC
1864–1901

La Passagère du 54, 1895
Lithograph
23$^1/_2$ x 15$^1/_2$ in. (59.7 x 39.4 cm)

Gift of Mr. and Mrs. James H. Beal,
55.36.1

RUSSELL G. TWIGGS
1898–1991

Monoprint No. 2 (Dance I), 1952
Serigraph
20 x 12$^1/_{16}$ in. (50.8 x 30.6 cm)
Signature: Russell Twiggs (lower
right)

Gift of Mr. and Mrs. James H. Beal,
55.36.3

Unfolding, 1950
Oil on Masonite
35$^3/_4$ x 14 in. (90.2 x 35.5 cm)
Signature, date, inscription: Twiggs
50 (lower left); Unfolding Russell
Twiggs 1950 (on reverse)

Gift of Mr. and Mrs. James H. Beal,
55.36.2

What Immortal Hand or Eye?, 1956
Watercolor on paper
21$^1/_2$ x 29 in. (54.6 x 73.7 cm)
Signature, date: Twiggs 56 (lower
right)

Gift of Mr. and Mrs. James H. Beal,
65.1.3

RICHARD H. WILT
1915–1981

Harris Point Pine, Maine, n.d.
Watercolor on paper
30 x 22$^1/_8$ in. (76.2 x 56.2 cm)

Gift of Mr. and Mrs. James H. Beal,
59.28